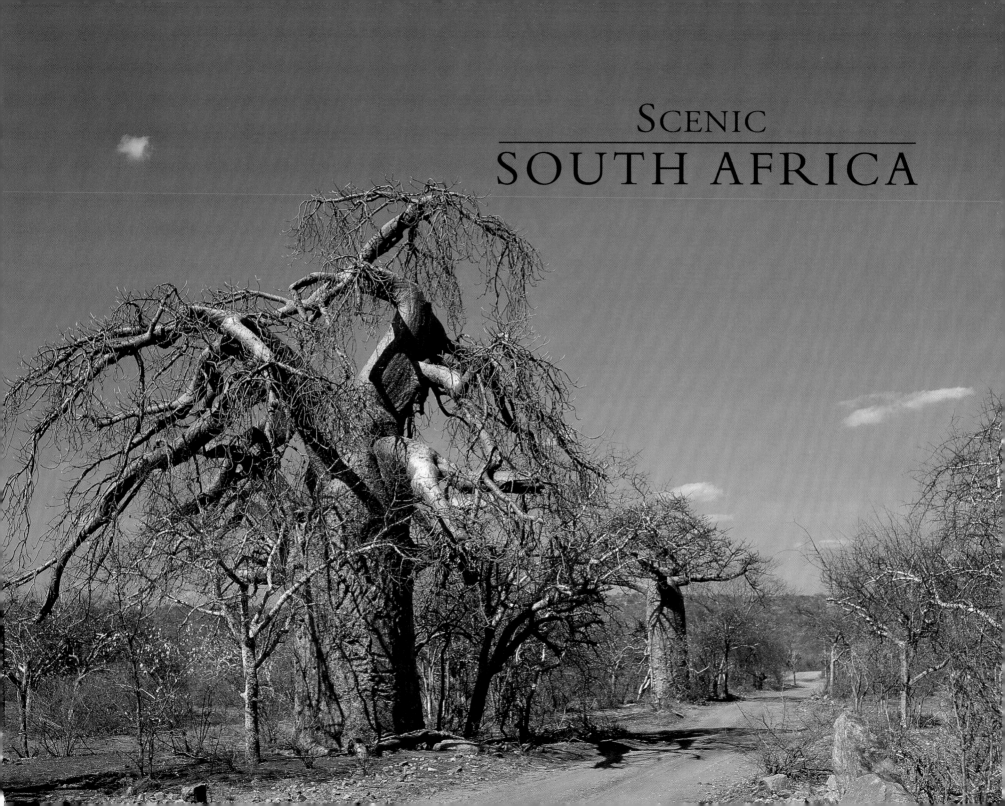

SCENIC
SOUTH AFRICA

SUNBIRD
PUBLISHING

First published 1998

Publisher Dick Wilkins
Editor Brenda Brickman
Designer Peter Bosman
Production Manager Andrew de Kock

Reproduction by Unifoto (Pty) Ltd, Cape Town
Printed and bound by Tien Wah Press (Pte) Ltd, Singapore

ISBN 0 62022 617 X

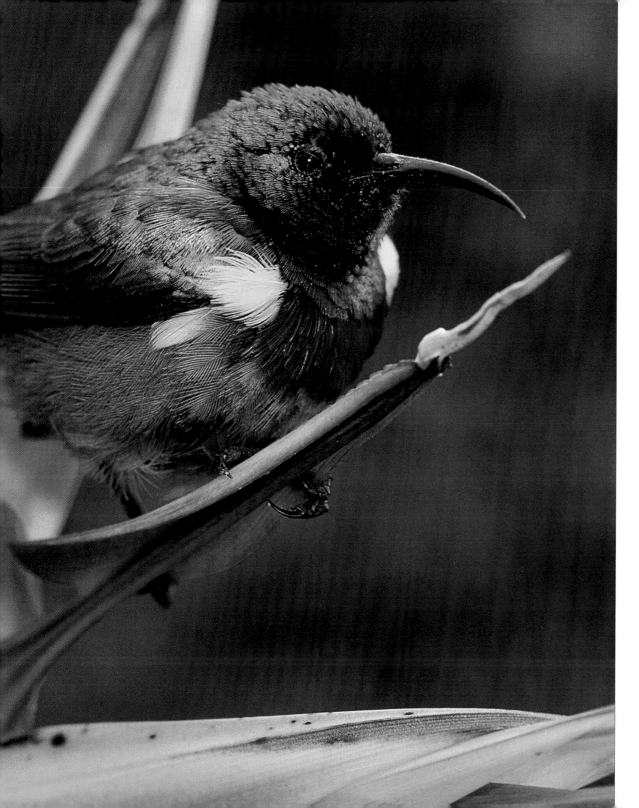

Front cover *The face of Cape Town's Table Mountain seen from the beach of Bloubergstrand.*
Title page *Phantom-like baobab trees dot the bushveld.*
Opposite *The Karoo is bathed in the golden hues of Africa.*
Left *The dazzling plumage of the sunbird.*
Above *Evening settles over the Mkuzi Game Reserve.*
Page 128 *An African moon rises over the Orange River.*

Introducing South Africa

Embracing two apparently different worlds – one embodying the ancient legend of sun-drenched Africa and the other the exciting whirl of a new and vibrant democracy – South Africa remains true to the spirit of both. This is a nation not only of extraordinary cultural diversity, but one blessed with an unsurpassed natural heritage and the undisputed jewel in the sub-continent's illustrious crown is the Mother City of Cape Town. Swathed in more than three centuries of colourful history, the varied ancestry of the city has ensured that its streets are lined with a delightful mix of the ancient and the modern. On the seaward limits of the City Bowl – the area enveloped by Table Mountain, Lion's Head, Signal Hill, and Devil's Peak, and the waters of Table Bay – lies what was once the old harbour and dockland, from which has mush-roomed an exciting nucleus of entertainment, shop-ping and fine dining. The Victoria & Alfred Waterfront development on this 'Gateway to Africa' is the hub of Cape Town's social activity and beyond the confines of the renovated harbour warehouses of the Victoria Wharf shopping mall is an equally enticing collection

of pubs, bistros, fast-food stalls, impressive hotels, and pleasure boats offering cruises into Table Bay and further afield to the gleaming coves that line the Atlantic shoreline.

Beyond bustling Sea Point lies a pristine stretch of coast lined with the immaculate beaches for which the peninsula is world renowned. The breathtaking sunsets and sea views make the mansions and beach houses of Camps Bay, Clifton, Bantry Bay and Llandudno much sought-after residential proper-ties. Equally beautiful but in a more rustic sense is the old fishing and timber village of Hout Bay, with its flourishing fleamarket trade and village stores. Almost lost in the mists which occasionally roll in from the sea, the village remains a haven for home-based industries, artists, craftsmen and, of course, the local fishing industry. Hout Bay (its name is derived from the Dutch word for 'wood') echoes the gypsy-like character of many of the more rural suburbs that stretch along the peninsula's east coast. En route to the Cape's most southerly point on the other side of spectacular Chapman's Peak Drive lies the Noordhoek valley, famed for its immaculate shore and a virginal land-scape. This rural retreat borders the most impressive of the Cape's natural sanctuaries, the Cape of Good Hope Nature Reserve, which attracts nearly half a million visitors annually and stretches some 40 kilometres along the False Bay coast. More than a thousand species of flora and an endless variety of wildlife inhabit the 8 000 hectares of the reserve, among them reptiles, birds and mammals such as rock hyraxes (or dassies),

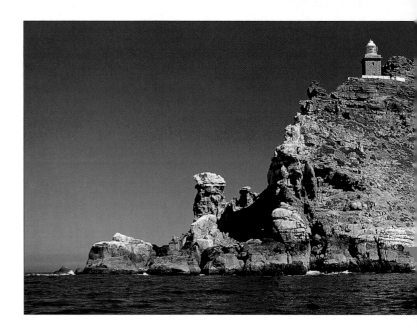

baboons, Cape foxes, and bontebok. Also within the confines of the reserve is Cape Point, and the waters of the marine reserve are home to fish, Cape fur seals, dolphins, and even migrating whales which visit False Bay between May and November in order to calve. The superlative beauty of Cape Point and its reserve is girded by high sea cliffs and the awesome view from these 300-metre (985 feet) precipices extends all the way to Simon's Town, St James, Muizenberg and beyond. Inland from the rugged coast is the green-shrouded mountain range that has given rise to the National Botanic Gardens at Kirstenbosch. The wild splendour of · Kirstenbosch stretches across 500 hectares of Table Mountain's eastern slopes, and the nearly 7 000 species of indigenous flora offer a wonderland of fragrance, colour and birdsong.

Left *A band of minstrels with painted faces and vibrant costume enchant holidaymakers at the New Year festivities.*
Above *The steep and rugged cliffs of Cape Point belie the stormy nature and crashing waves of the Atlantic at its feet.*

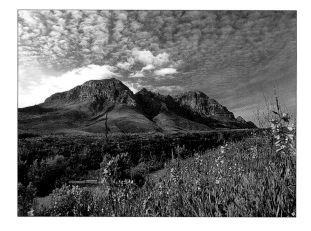

Most conspicuously beautiful of the wooded vales of these foothills is Constantia, planted with the Cape's first vineyards and home to some of the city's most highly regarded restaurants. Lined with flourishing vines and luxuriant woodlands, the winding roads cling to the Constantiaberg, passing the prestigious wine estates of Buitenverwachting, the 200-year-old Klein Constantia, and majestic old Groot Constantia which form part of the peninsula's only wine route.

It is, however, the grand old estates of the Boland that have earned the Cape its reputation as one of the world's finest wine-producing areas and it is here, among the lush hills of Paarl, Stellenbosch and Franschhoek, that the very best of South African vines are cultivated and its wines bottled for export.

In stark contrast to the green winelands inland, although no less spectacular, is the rocky West Coast. Still the flourishing fishing centre it has been since it was first settled, the wild and rugged shoreline is rich in both flora and fauna and the sea here abounds with marine life. Sheltered by the mountains of the Cederberg, it is this simple landscape of sandveld, renosterveld and fynbos that erupts into fields of colour between August and October when the land emerges from its slumber and the ericas, restios and proteas of the unique Cape Floral Kingdom burst into bloom.

Beyond the sheltering mountain range is the considerably less hospitable semi-desert Karoo that stretches across the Cape interior toward the east. This harsh and rather arid veld comprises the Great Karoo and the contrasting wilderness of the Little Karoo to the east. On the other side of the Outeniqua mountains extends the picturesque Garden Route and the unspoilt stretch of the Wilderness Lakes Area. At the foot of the Outeniqua range, the 10 000 hectares of the Wilderness National Park and the natural grandeur of the Outeniqua and Tsitsikamma ranges are home to birds, baboons, otters and small buck, which seek refuge in the crystal waters of its streams and the giant yellowwoods of its forests.

Of all the entrancing stops along the Garden Route, the finest must be Knysna and the adjoining National Lake Area, a verdant stretch – encompassing the town, the famed 36 000-hectare forest, lagoon, and the Heads – that continues to yield stinkwood and yellowwood from its natural forests, and oysters and other seafood delicacies from its bountiful ocean. Nearby Plettenberg Bay, on the other hand, is the most fashionable of the Garden Route's holiday spots and, during high season, its beaches are dotted with sun-seekers.

Beyond the Garden Route lies the sometimes volatile and sometimes yielding shore of the Eastern Cape. The rural interior is punctuated with small towns and traditional villages of the Xhosa, while the simple world of the Transkei and its Wild Coast is a remarkably untamed expanse of white beach and rolling hills that extend right into KwaZulu-Natal and mark the upward rise of the Drakensberg.

Durban is the heartland of KwaZulu-Natal's north and south coasts – a metropolis of modern architecture and centuries-old edifices dating to its distinctly colonial past. The wide streets are dotted with an assort-

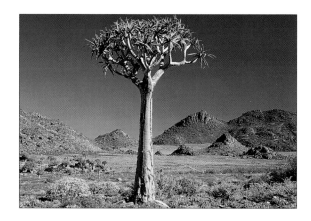

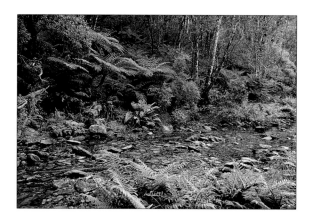

Left *Towering over the painted face of an otherwise arid landscape stands a proud kokerboom.*
Above *Captured in spectacular colour, the mountains of the Helderberg of Somerset West.*
Right *Fern-covered glades of Jubilee Creek, Knysna Forest.*

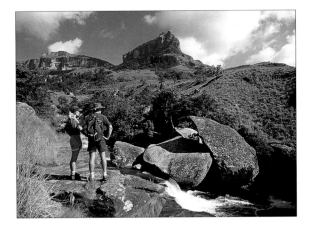

ment of timeless old structures dedicated to local trade and leisure, much of which centres around either the 900-hectare bay or the beaches that line its coast. Graced with a delightful blend of urban and rural Africa, the vibrant and exciting cityscape is, however, matched by the equally resplendent countryside beyond, bedecked as it is with glades of indigenous trees and carpets of wildflowers. This is also the setting of the legendary Valley of a Thousand Hills, an undulating sweep of slopes and gradients steeped in a turbulent history of long-fought battles and wars braved by tribal warriors. Rich in wildlife and indigenous flora, KwaZulu-Natal is dotted with some of the country's finest national and private reserves. Supreme among these is the Hluhluwe-Umfolozi Game Reserve, a wild expanse grazed by buffalo, zebra, giraffe and the white rhino. But this land is also the traditional home of the Zulu people, an Nguni-speaking group that has inhabited the countryside for centuries and, according to ancient beliefs, whose ancestors still watch over

Top Hikers hit the trails of Royal Natal National Park.
***Right** The rolling Mpumalanga landscape is reflected in the tranquil waters of the Badplaas Nature Reserve.*

nature's bounty. Small pockets of tribal communities continue to live the life of the ancients in rural villages dotting the countryside that leads from the rugged coast to the looming wonder of the Drakensberg.

The most significant of the great heights which comprise the Great Escarpment is the mighty Drakensberg which separates the coastal stretch from the high-lying interior. The caves which have been carved from the many peaks of the 'Dragon's Mountain' boast an array of San wall paintings, while the foothills are studded with retreats aimed at attracting adventurers who visit the mountains to hike, ride, and fish. During the summer months, the terrain is blanketed in emerald green, but it is during the icy winter months that the vista is at its most exceptional and, as temperatures plummet, snow covers the ground and icicles begin form.

The Greater St Lucia Wetland Park, with its shallow Lake St Lucia and its intricate network of rivers, lagoons and coastal forests form part of Maputaland — the country's most exceptional marine wilderness — is bound in the west by the Ubombo and Lebombo mountains and, to the north, by Mozambique. The entire area, including the Sodwana Bay National Park

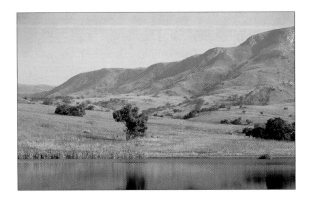

and Kosi Bay Nature Reserve — and the Maputaland Marine Reserve along the shore between the two — boast enormous biodiversity, and as such remain extremely sensitive to human intervention.

This is the tropical world of KwaZulu-Natal and, as the Natal Drakensberg continues its journey, it traverses the Mpumalanga Escarpment and gives way to the dramatic and breathtaking rock formations of the Lowveld. It is here that eagles soar and rivers course over the steep inclines of the Blyde River Canyon, a wild and open space embraced only by the ridges of the escarpment. Although the broader region appears comparatively arid, these canyons are blessed with rivers, streams and waterfalls, and the sheer beauty — coupled with the abundance of trout — attract holiday-makers, fly-fishing enthusiasts and nature lovers alike.

It is here, too, that the early gold-diggers sought their fortune, and the small, aptly-named town of Pilgrim's Rest still stands in tribute to those early pioneers. Although considerably more sedate than in the wild-catting days of its founders, the town is seemingly lost in its heyday: guided tours take visitors through the dusty streets past general dealers, old mine cottages and saloons that echo the town's Victorian origins.

The highlight of the Lowveld is undoubtedly the 'African Eden' to the east, a bountiful land bound by the Crocodile River in the south, the Limpopo in the north, and the Lebombo Mountains in the east. Acclaimed as one of the greatest parks in the world, the nearly 20 000 square kilometres covered by the Kruger National Park teems with African game of every description. Apart from nearly 2 000 plant species and 400 tree species — including marula, mopane, and baobabs — that cover the rugged, sometimes dry sometimes lush veld, the Park is

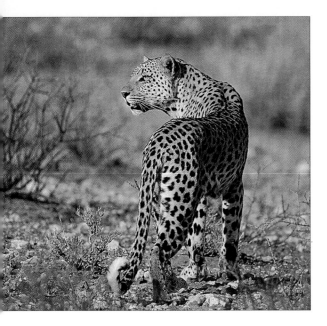

home to approximately 137 mammal and an incredible 500 bird species, with more than 100 reptile, 30 amphibian and nearly 50 freshwater fish species, and a prolific insect life which includes over 200 types of butterfly. Here, virtually unfettered by man-made boundaries, the Big Five (lion, elephant, buffalo, leopard and rhino), zebra, giraffe, wildebeest, crocodiles and hippo are left to roam their natural habitat.

Bordering this great park are a number of smaller private reserves that enjoy just as magnificent a setting, and offer the finest in upmarket bushveld experiences. Wide open spaces, well-appointed leisure areas and comfortable, airy accommodation cater largely for foreign visitors and a well-heeled clientele from nearby Johannesburg. As the centre of South Africa's lucrative mining industry, the 'city of gold' is a great metropolis and the country's economic heart. Johannesburg is undoubtedly the most cosmopolitan of all South Africa's cities, and its pulsating rhythm is alive with bright lights, resounding song and constant action. The origins of this irrepressible city lie on its goldfields, charmingly captured and recreated at nearby Gold

Reef City – a step back in time to a long-gone era of pennywhistles, hoop skirts and horse-drawn carriages.

No less dynamic, but considerably more sedate is picture-postcard Pretoria, home of the stately Union Buildings and a seat of national government. Having played a pivotal role in the country's stormy past, this beautiful city is lined with ranks of purple-flowered jacarandas and is slowly rejuvenating itself to accommodate the changing and vibrant world of the new South Africa. The earliest settlers in this part of the world appear to have been the Ndebele, an Nguni-speaking nation most acclaimed for its fine art and traditional way of life – even in the modern South Africa. An enormous leap from this authentic look at real Africa is the fantasy which dominates the Highveld to the south. This is the world of The Lost City, a magnificent oasis, every inch of which was constructed by the power of imagination. The creators of this magical land of gilded turrets, towering palms and marbled plazas have bestowed upon it a legend of ancient African tribes steeped in fancy rather than fable, and it remains the country's premier resort. Although the central regions of South Africa may seem quite desolate, the terrain is endowed with the country's most breathtaking vistas and landforms of exceptional magnitude and beauty. Nowhere is this more true than in the Free State, a wilderness of warm earthy tones –

occasionally sprinkled with colourful fields of wild sunflowers and cosmos – and rocky outcrops such as the two imposing buttresses towering over the Golden Gate Highlands National Park.

To the far west and covering the central regions that border Namibia, the rock-strewn landscape along the Orange River is arid, but the great river gives to it a life of its own. The turbulent waters tumble headlong towards the sea and, en route, crashing down down the 9-kilometre-long gorge in a torrent of white water that is the Augrabies Falls. In the northwestern corner of South Africa and extending beyond its borders into both Namibia and Botswana lie the red sands of the Kalahari, a wasteland rarely blessed with good rains. Once the hunting and gathering grounds of the ancient San people, today the arid landscape is home only to small groups of gemsbok, kudu and other species which roam the remote dunes.

From the gentle vineyards of the Cape and the rolling hills of KwaZulu-Natal to the dramatic buttresses of the Drakensberg and the stark veld of the Kalahari, these landscapes and faces of South Africa epitomise the very essence of life in a vibrant and dynamic world of colour, textures and sounds.

Top left A tireless and ferocious hunter of the African bushveld, the leopard of the arid Kalahari Gemsbok National Park on the country's northern borders.
Right Salt crystals form a criss-cross network across the surface of the Soutpan in the Kalahari.

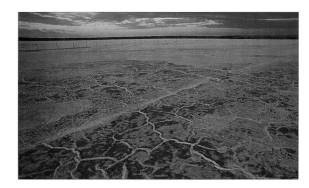

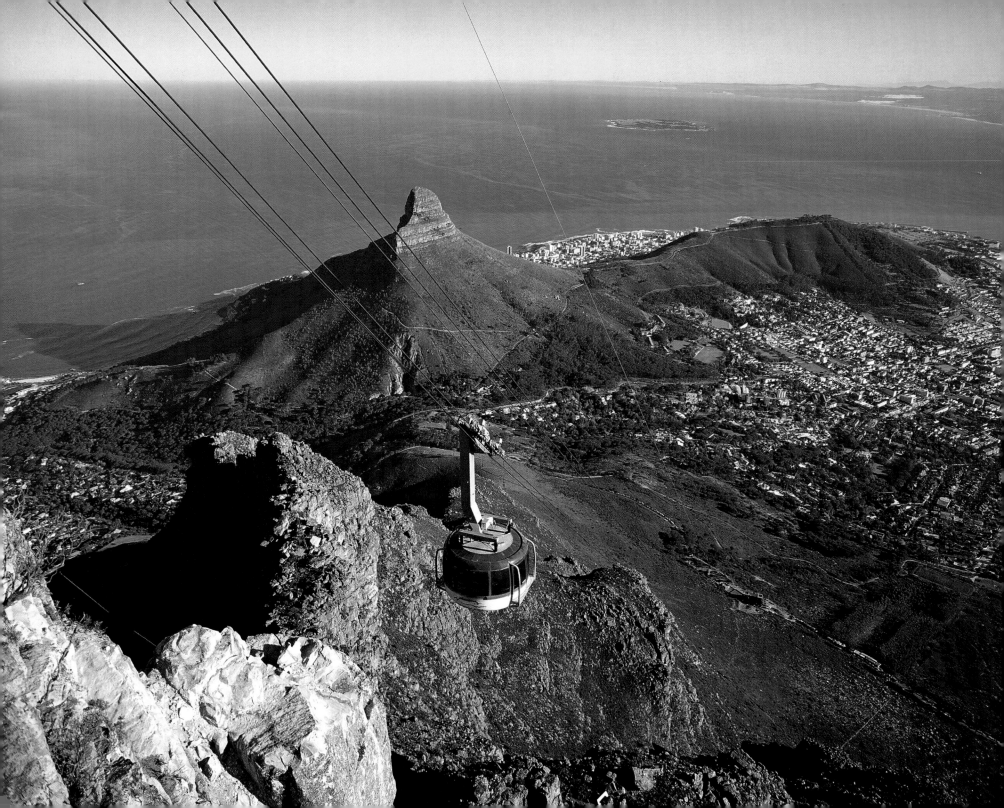

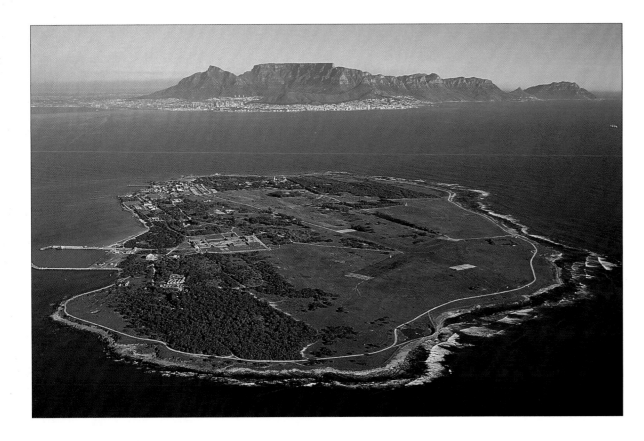

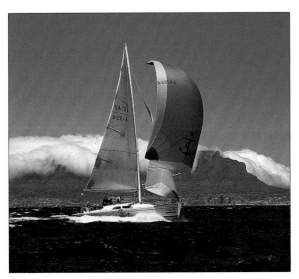

Opposite *The shiny new cable cars ferrying visitors to the world-famous summit of Table Mountain add a contemporary element to this sandstone massif formed millenia ago.*
Above *The exposed terrain of Robben Island echoes the despair and suffering of the many political prisoners held there during more turbulent times in the country's history.*
Left *Cape Town's harbour is a major stopover on some of the world's most prestigious yachting routes, and it is in a usually blustery Table Bay that the premier local round-the-buoys regatta of Rothmans Week is held in December every year.*
Right *In the days prior to the erection of the lighthouse on Robben Island, many ships met their fate on the island's treacherous coastline.*

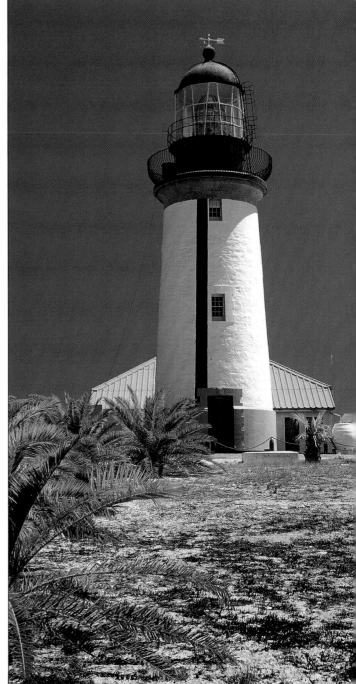

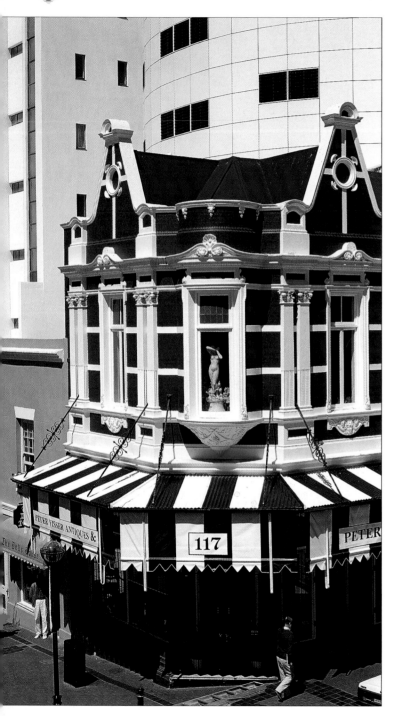

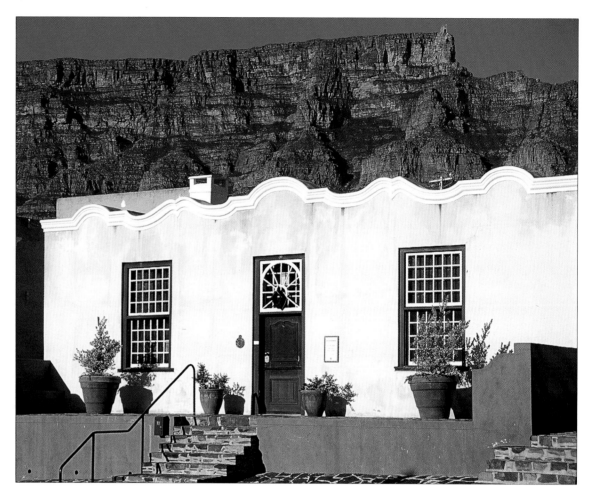

Left and above *Cape Town's architecture is interspersed with glorious Victorian and traditional edifices inspired by its Cape Malay residents, such as the Bo-Kaap Museum dedicated to the local Muslim community.*

Opposite *The kramats that are found throughout the peninsula, such as this one on Signal Hill, are holy shrines dedicated to religious leaders who brought the Islamic faith to the Cape.*

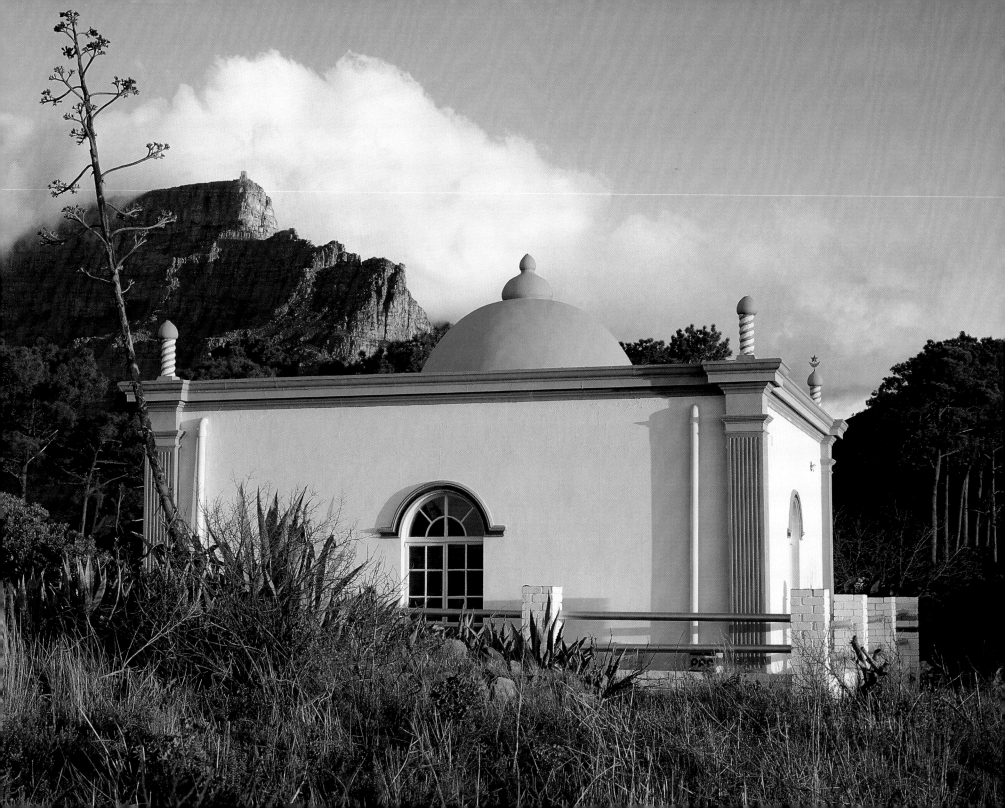

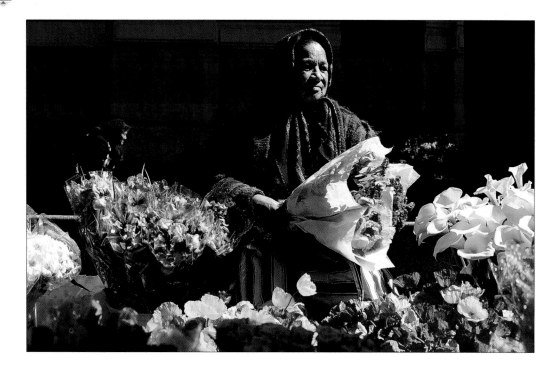

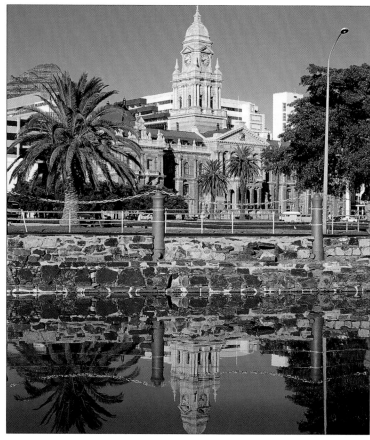

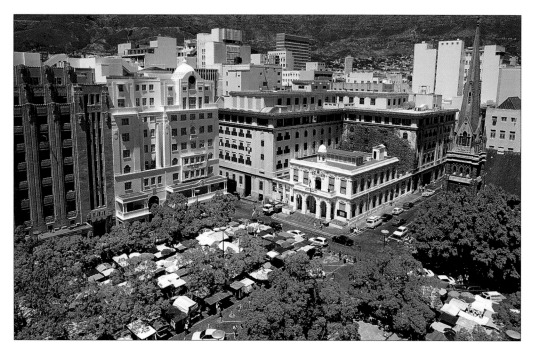

Top left *Cape Town is peopled with a blend of cultures and the legacy of each is reflected in the city's many faces, including the traditional flower sellers trading on Adderley Street.*

Left *Originally the colony's produce market, cobbled Greenmarket Square has long been a vibrant shopping haven, and the proposed facelift is destined to attract even more people to its pavement cafés and outdoor lifetsyle.*

Above *The majestic facade of old City Hall on the Grand Parade is reflected in the recently restored moat originally built to defend the Castle of Good Hope and the settlers of the early colony.*

Opposite *De Tuynhuys, today the city office of the country's president, was built in 1700 to accommodate visiting dignitaries and, although closed to the public, the formal gardens remain true to its colonial origins.*

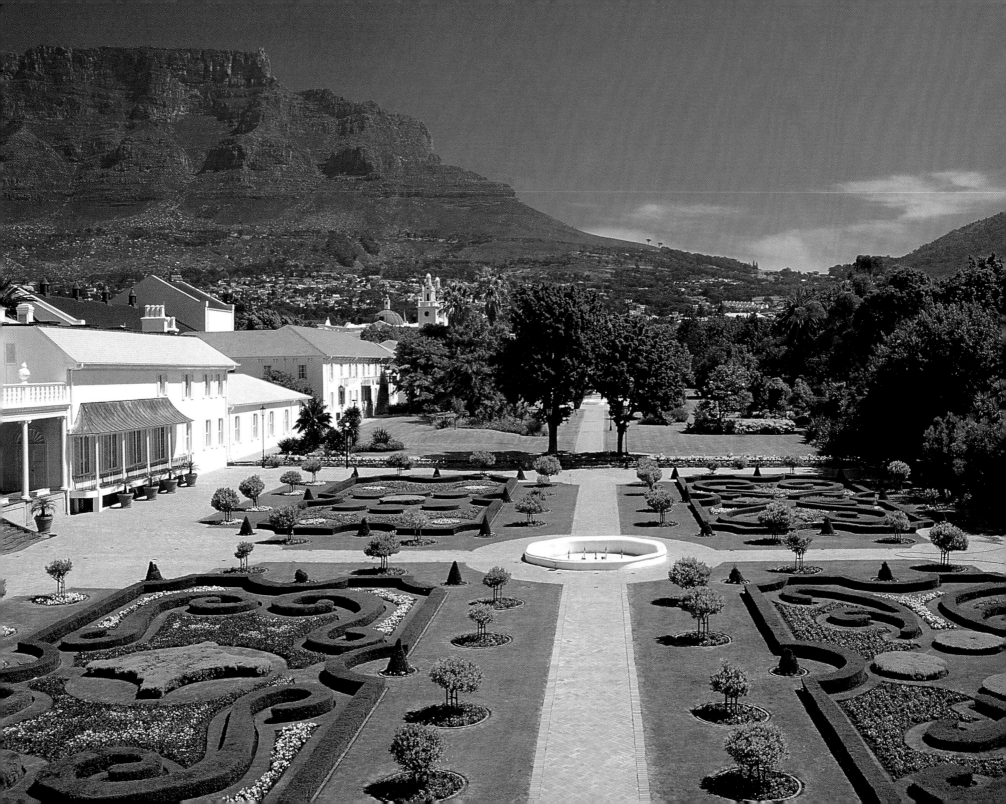

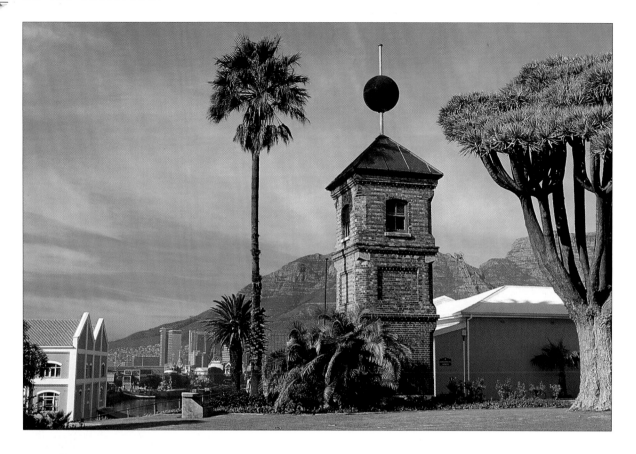

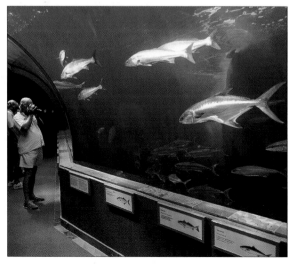

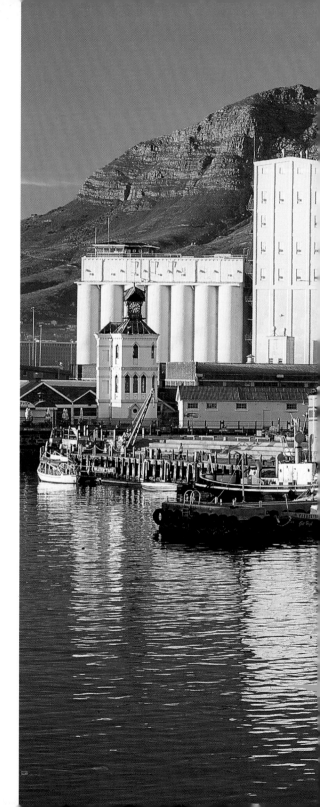

Above *The Time Ball Tower on the V & A Waterfront was once used by passing ships to set their clocks, but remains a constant reminder of the city's seafaring days of old.*
Left *The Two Oceans Aquarium is a fascinating marine wonderland of a glassed underwater tunnel, a tide pool, kelp garden, and an deep-sea tank which holds marine life from both the Atlantic and Indian oceans.*
Right *The Old Port Captain's Building on the V & A Waterfront's Pierhead overlooks Victoria Basin which, although dominated by a reproduction sailing ship of a bygone era, is the mooring for pleasure boats offering cruises into Table Bay and beyond.*

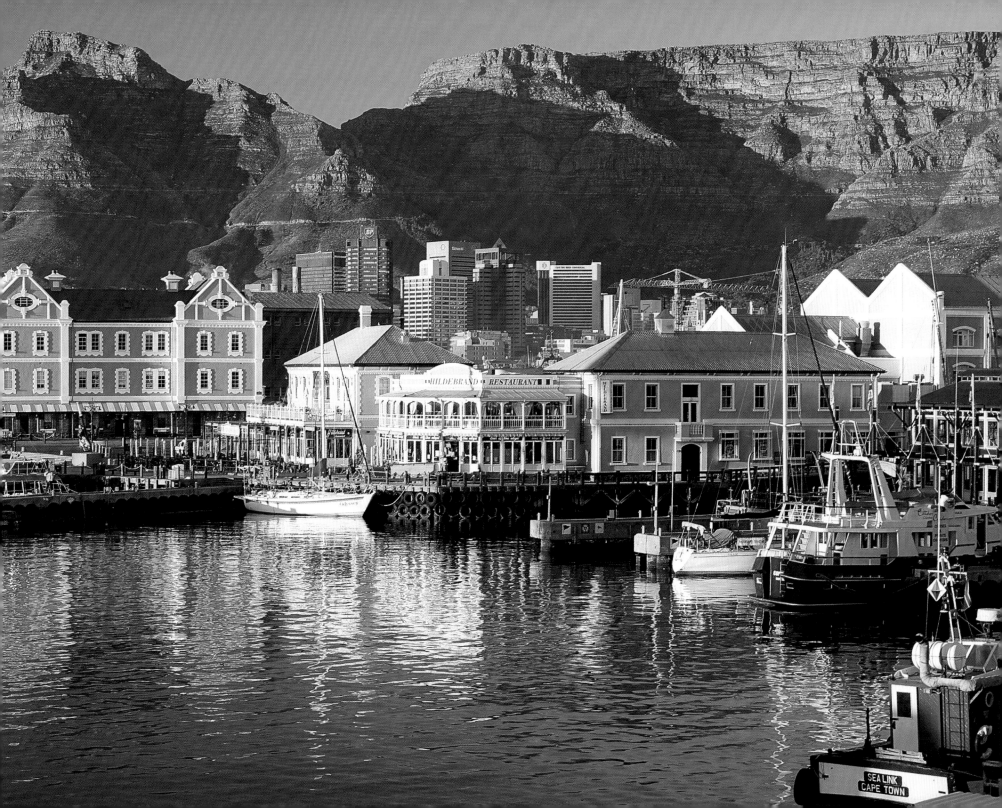

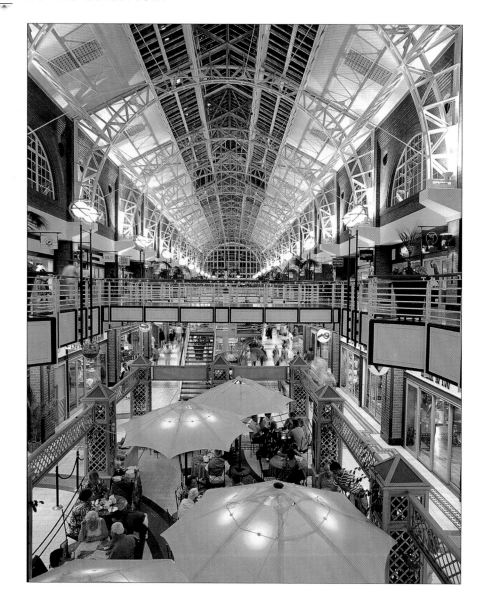

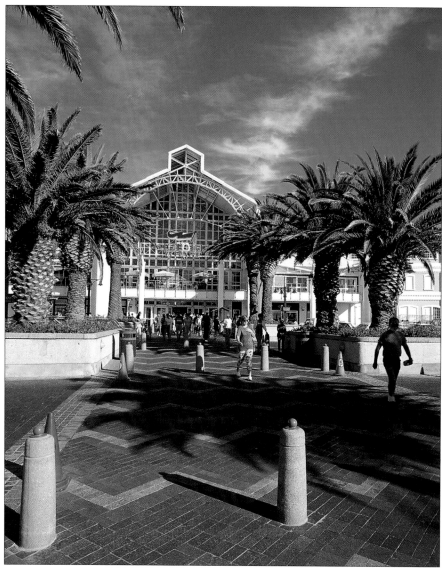

Above *Enclosed above by glass atria, the galleries of the V & A Waterfront's Victoria Wharf house trendy restaurants, chic fashion stores, and upmarket curio outlets visited by a fascinating parade of locals and visitors.*

Above right *The palm-shaded avenues of the V & A Waterfront are lined with restaurants, shops and pubs which form the throbbing heart of Cape Town's social life and a lively extension of the city experience.*

Opposite *Many of the city's exciting new developments are directed at the ever-increasing tourist trade, and the elegant Table Bay Hotel on the V & A Waterfront is a fine example of Cape Town's burgeoning hospitality industry.*

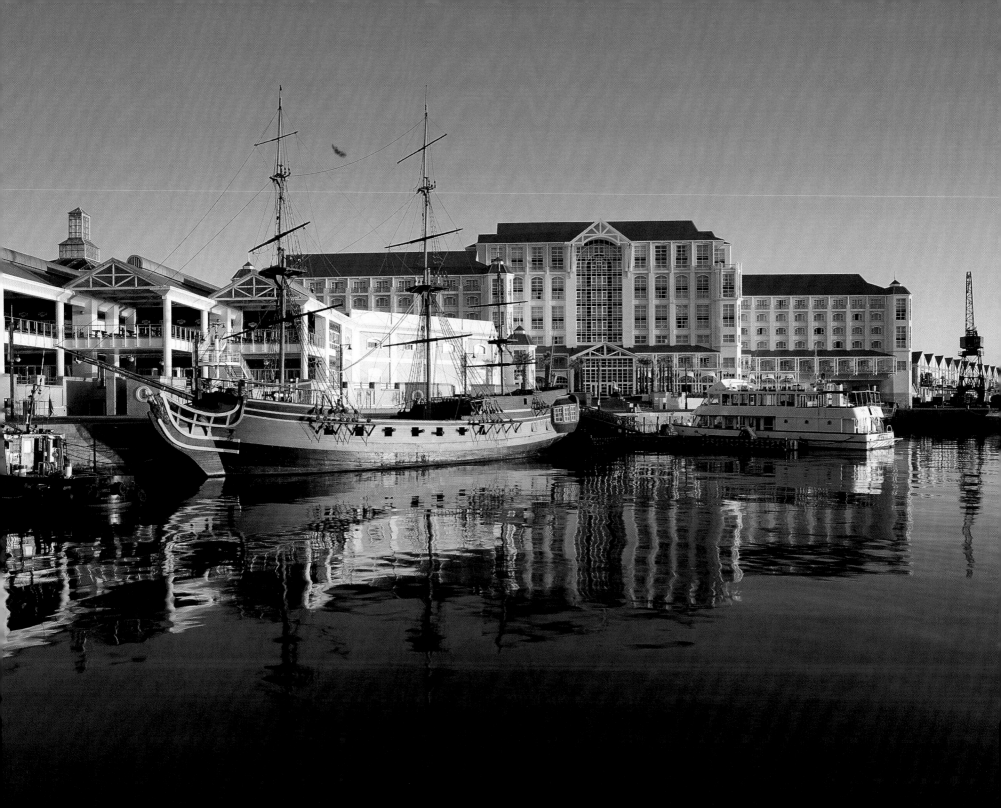

Right Unobstructed sea views and a gracious
mountain backdrop make the Atlantic suburbs of
Mouille Point, Green Point, and Sea Point popular
drawcards for both residents and visitors.

Overleaf left Given the magnificent views and
the gentle lapping of waves on its rocky shore, it
is little wonder that sought-after real estate in
Camps Bay, Clifton, Bantry Bay and Llandudno
is hard to come by.

Overleaf right The soft white beaches on the
peninsula's Atlantic seaboard are reminiscent of
the azure waters of the Mediterranean, and the
idyllic setting attracts many visitors to this coast.

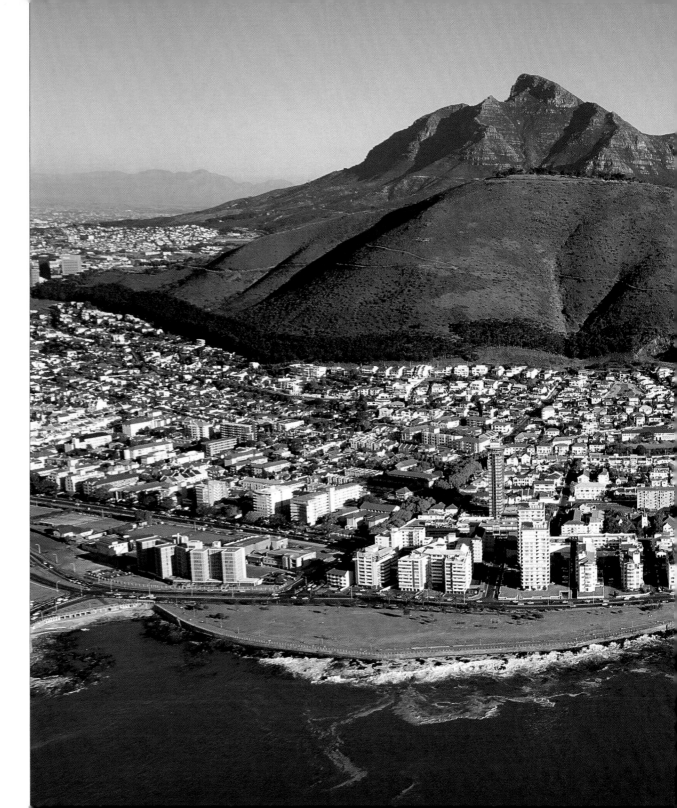

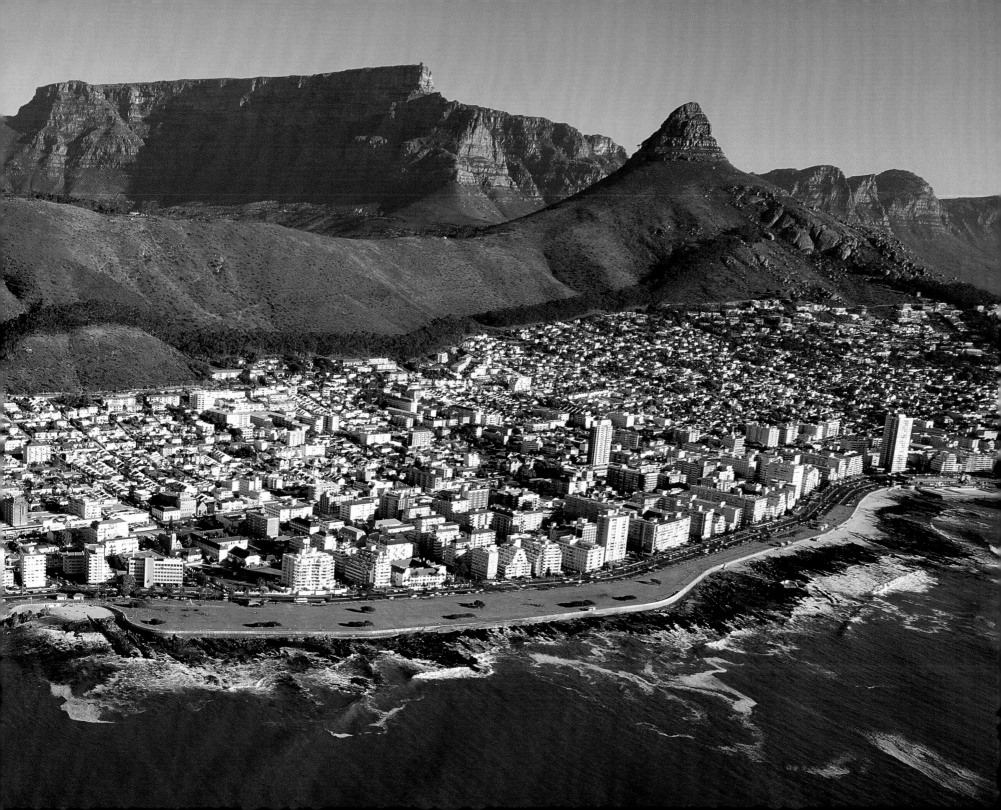

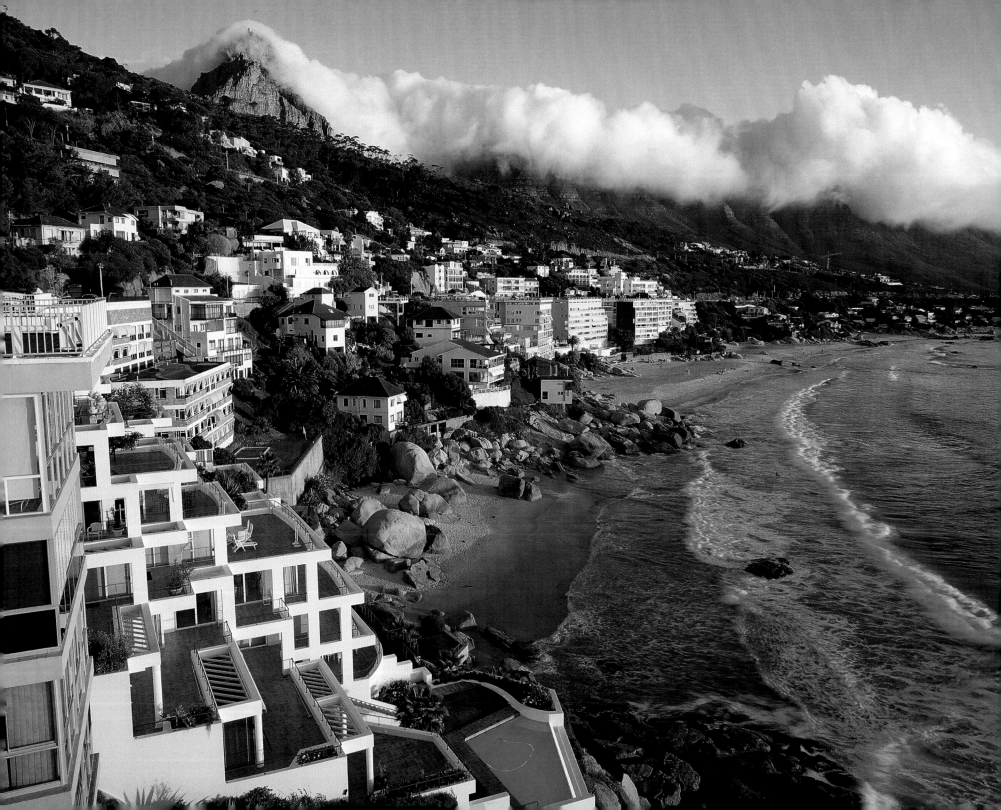

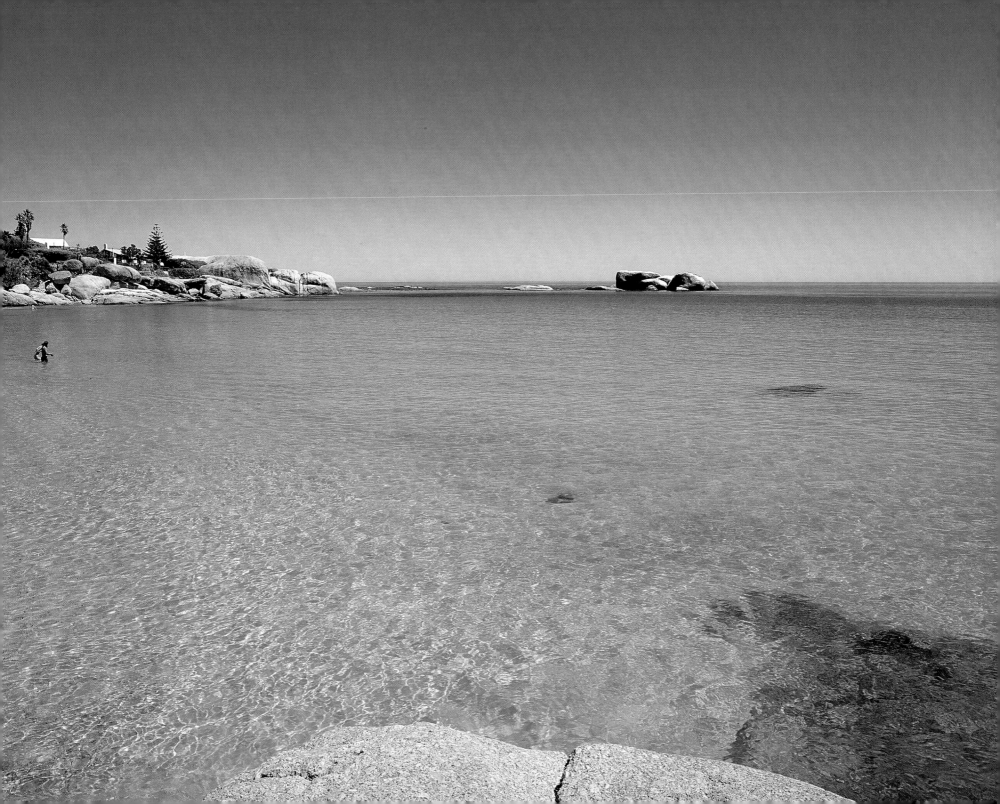

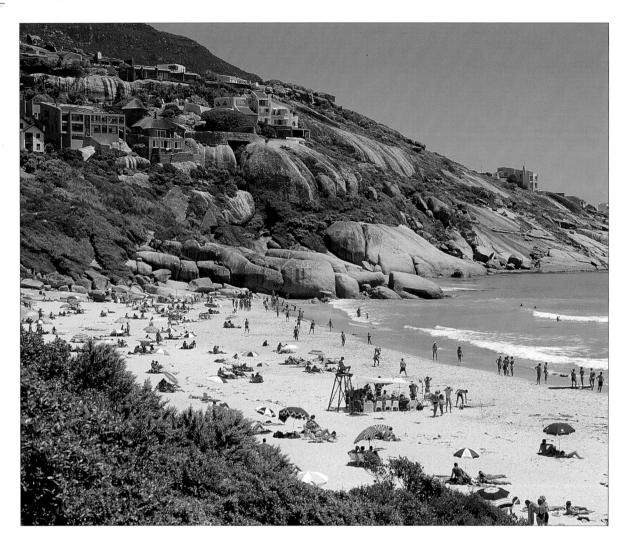

Above *Llandudno is blessed with pristine, sun-kissed beaches and is sheltered by the rockface of the Twelve Apostles that forms its backdrop.*

Right *Known throughout the world for its natural splendour, the Atlantic suburbs of Llandudno and Hout Bay beyond boast several secluded bays and gentle beaches.*

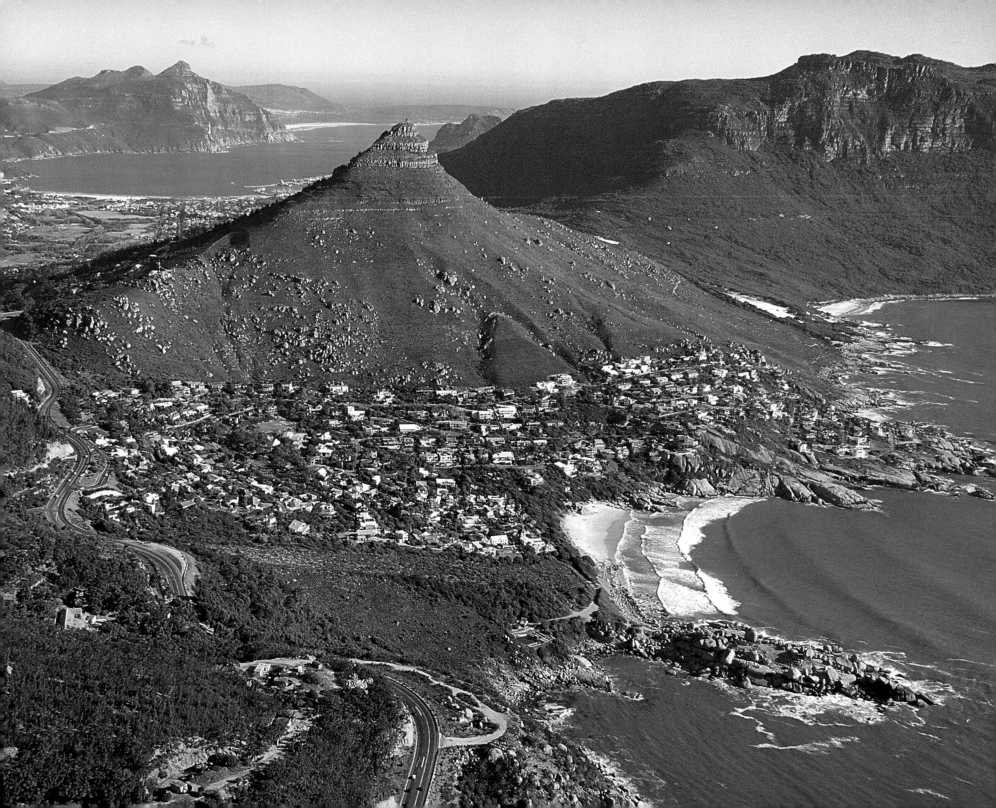

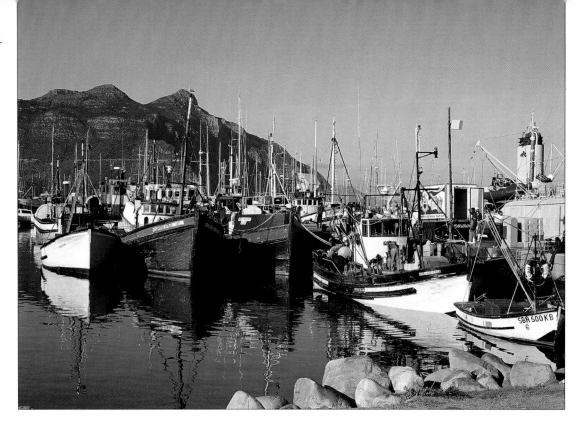

Left *From the small harbour at Hout Bay, colourful fisherfolk sell produce fresh from the sea, while the seafood delicacies harvested here are exported to destinations across the globe.*
Below *Chapman's Peak Drive was excavated from the mountain face by human hands and the view from here is one of the most spectacular of all the peninsula's scenic drives.*
Opposite *The coastal landscape of Noordhoek, fringed by small-holdings, shelters artists and other bohemian Capetonians intent on escaping the usual frenzy of city life.*

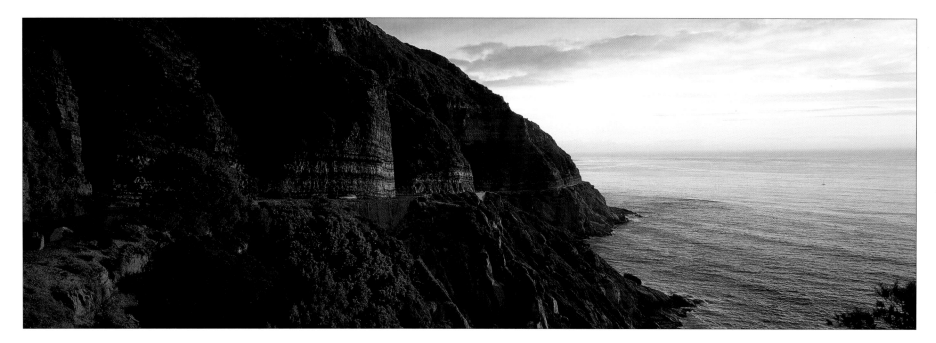

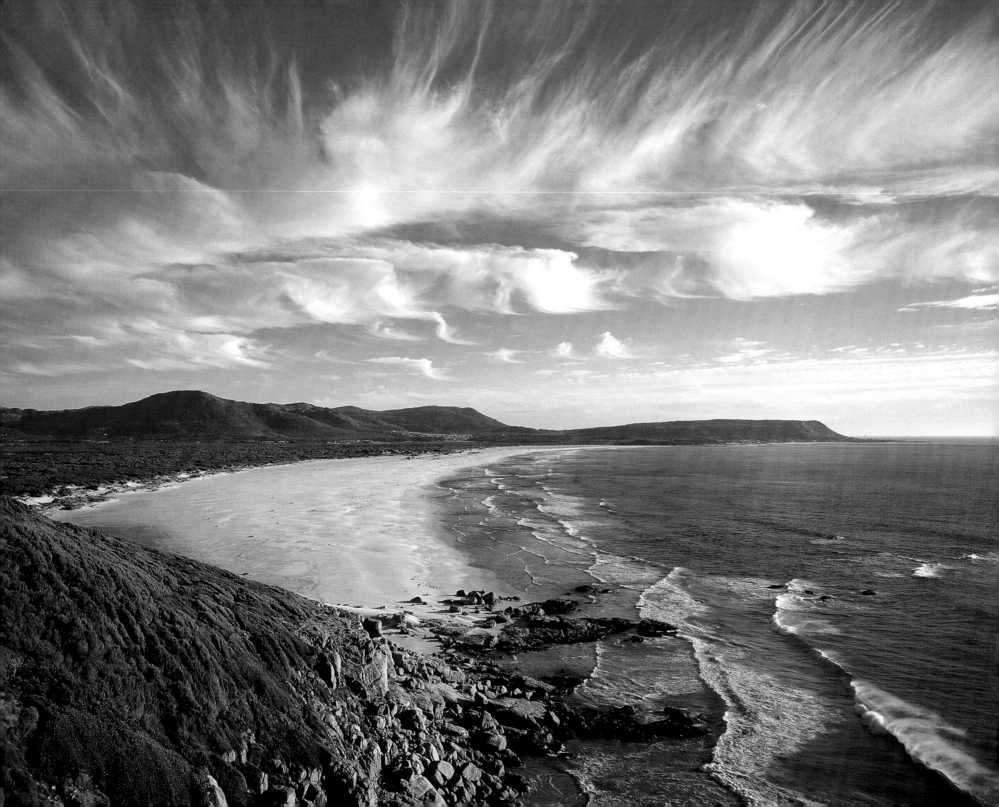

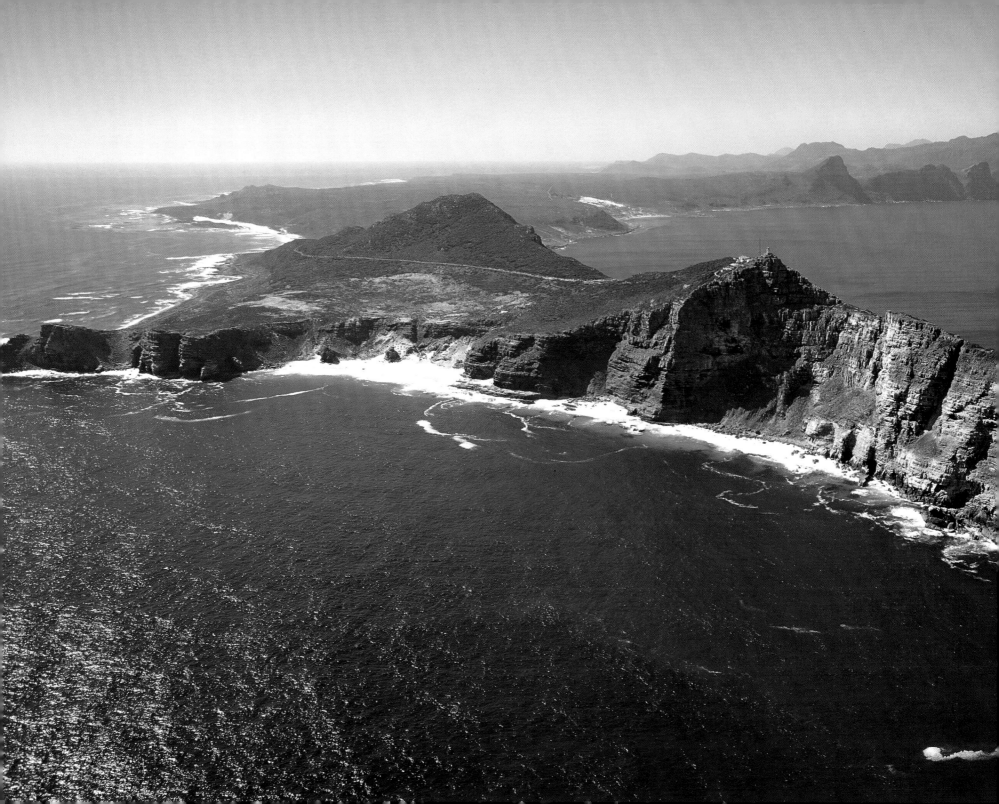

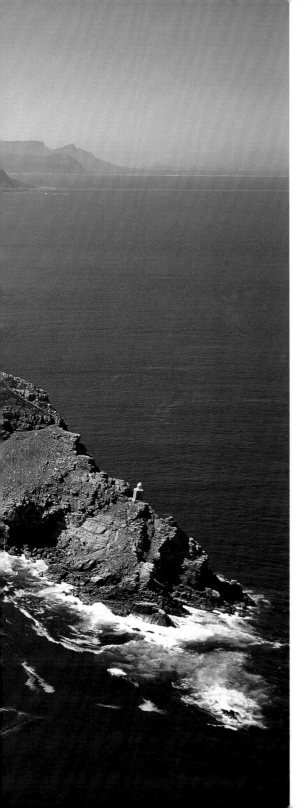

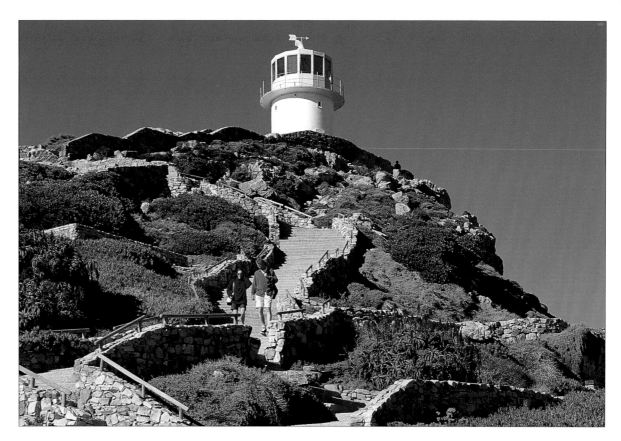

Left *The most significant of the peninsula's many conservation areas, Cape Point remains home to the wild animals and rare fynbos of this rocky coastline buffeted by the waves of the Atlantic.*

Above *With views that seem to stretch into eternity, the lookout at the Cape Point lighthouse, set high on the rocky cliffs, attracts thousands of visitors intent on capturing the vista on film.*

Right *The natural beauty and superlative views of Cape Point provide one of the wonders of the peninsula, and the area encompasses some of the finest expanses of fynbos vegetation and other Cape flora.*

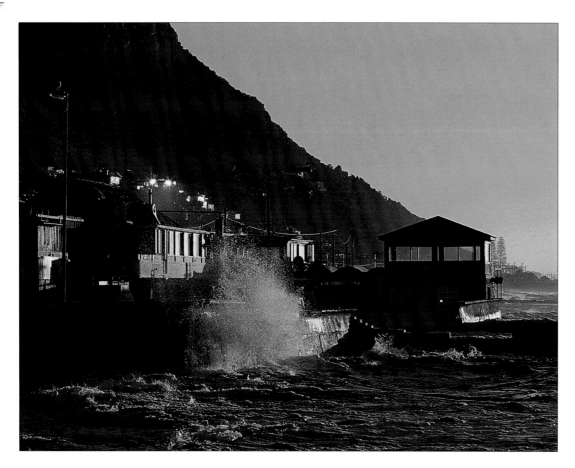

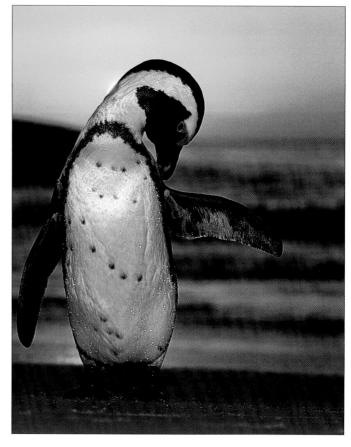

Top left *The cosy Brass Bell restaurant in Kalk Bay — its quaint streets lined with antique stores — offers the rare experience of dining just above the waves that crash on the rocks immediately below.*

Above *Sheltered from the ravages of the Atlantic, Boulders Beach near Simon's Town is home to a protected colony of jackass penguins, South Africa's only endemic penguin.*

Opposite *Unusually empty at sunrise, the popular leisure strip of Muizenberg beach is usually dotted with surfers intent on catching the first wave of the day.*

Overleaf left *Kirstenbosch was formally established as a botanic garden in 1913 after the grounds were left to the people of South Africa by statesman and entrepreneur Cecil John Rhodes.*

Overleaf right *Like much of the Constantia countryside, the vineyards of Buitenverwachting yield export-quality grapes used to make some of South Africa's finest wines.*

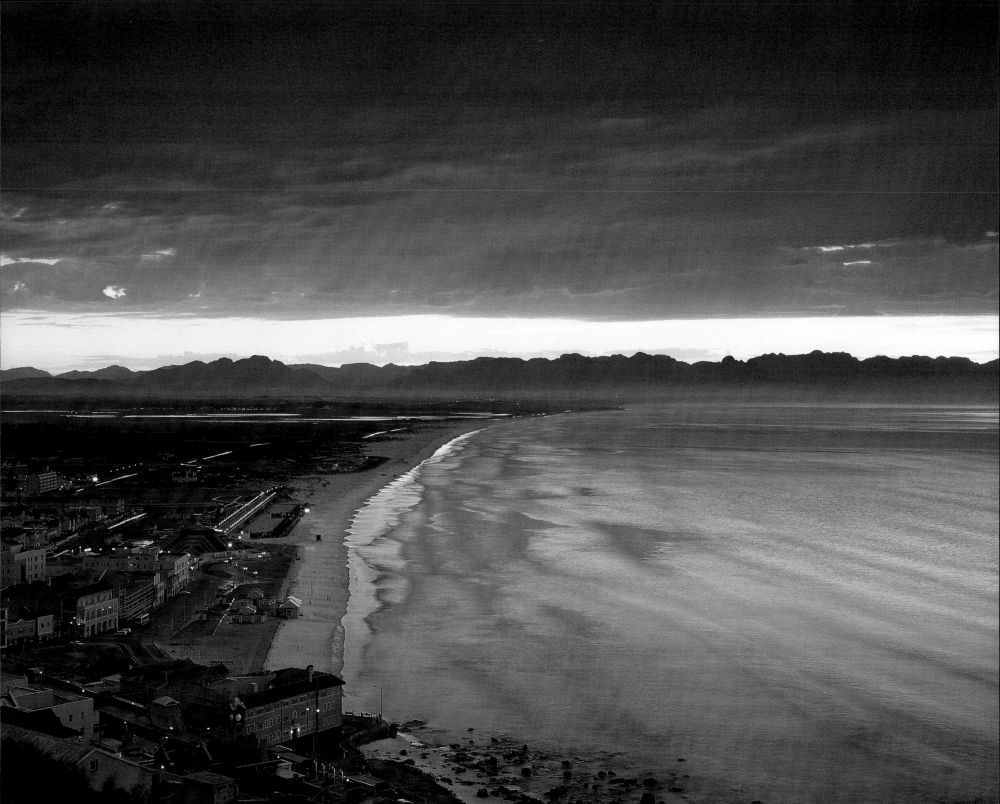

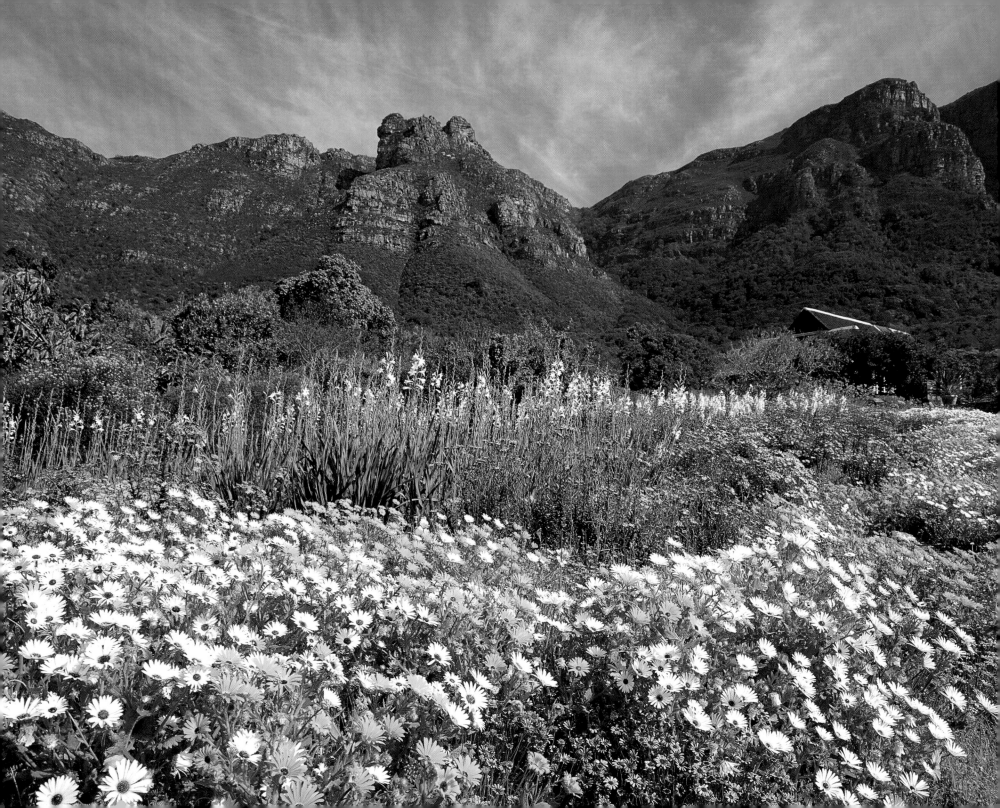

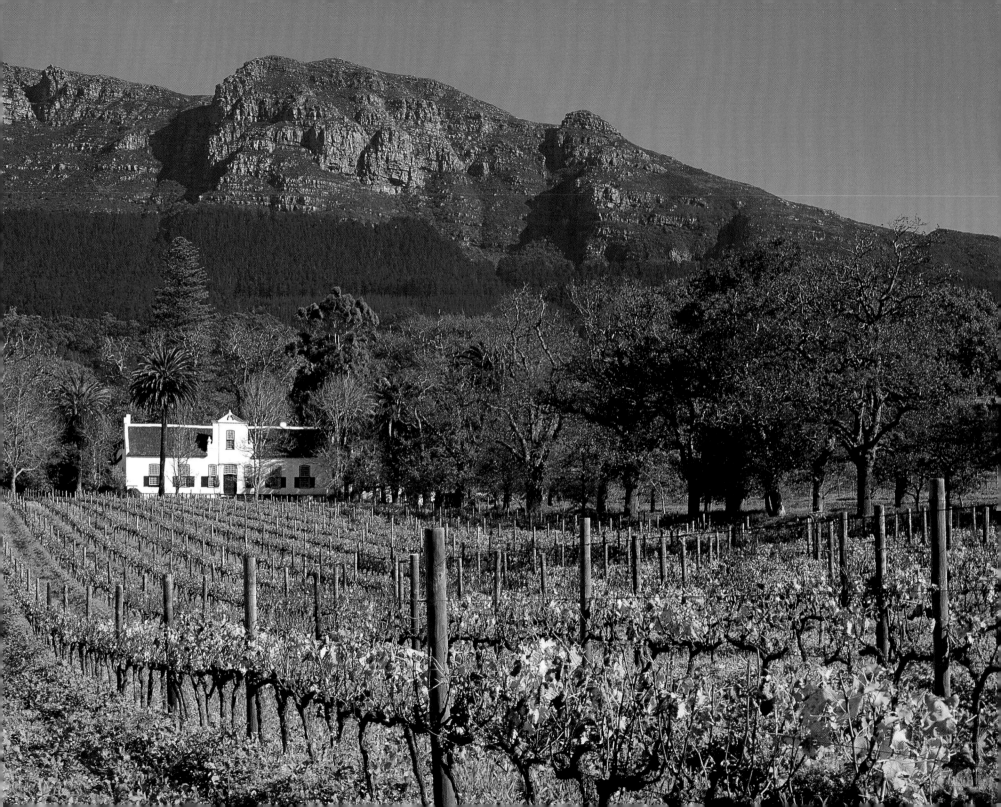

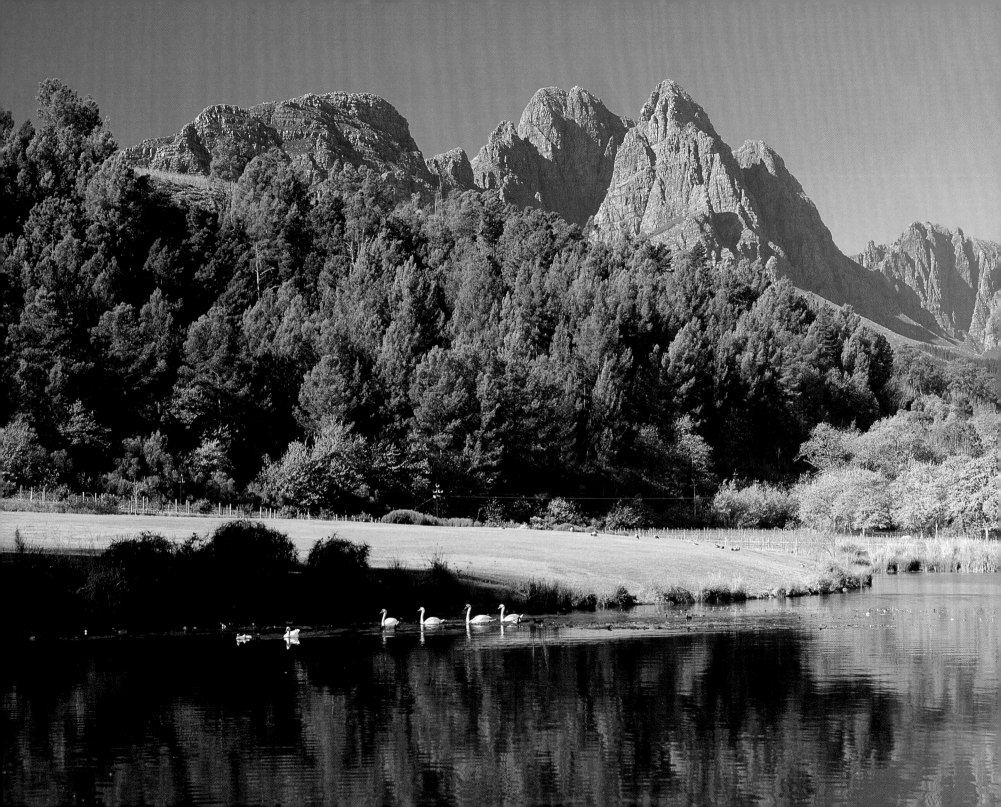

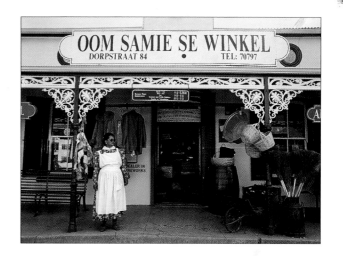

Left *The magnificent mountains and crystal waters of Jonkershoek Valley near Stellenbosch.*
Right *The most famous of all the quaint buildings on Stellenbosch's Dorp Street is Oom Samie se Winkel, the local general dealer which first began trading in handicrafts, preserves and farm implements in 1904.*
Below *The gracious old Oude Nektar homestead in the Boland's Jonkershoek Valley.*
Overleaf *The fairytale land of the Jonkershoek Valley.*

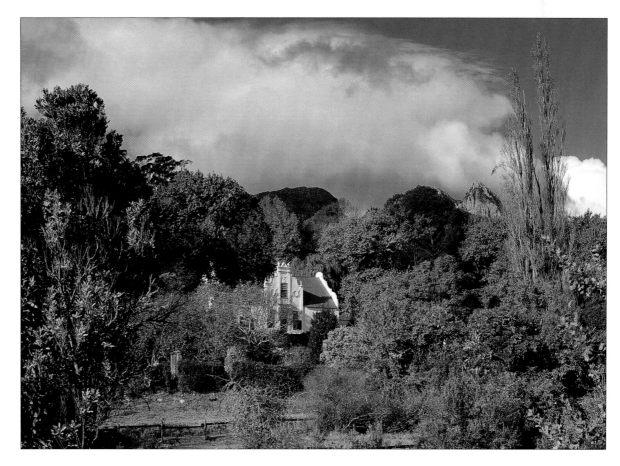

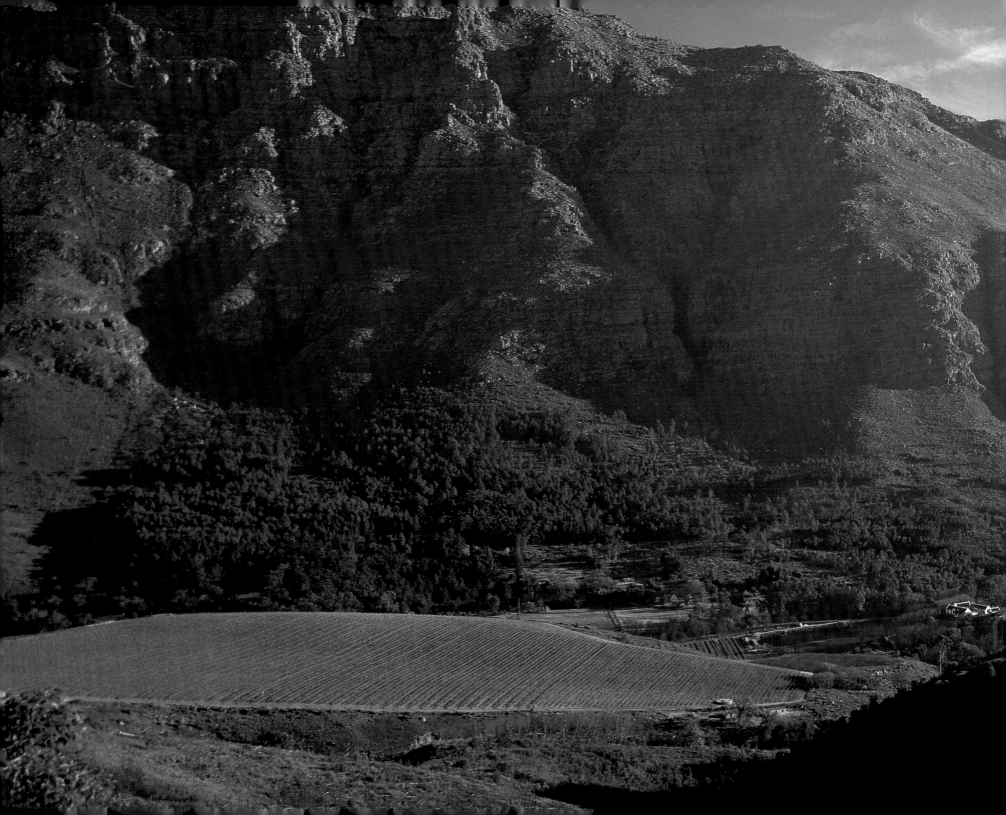

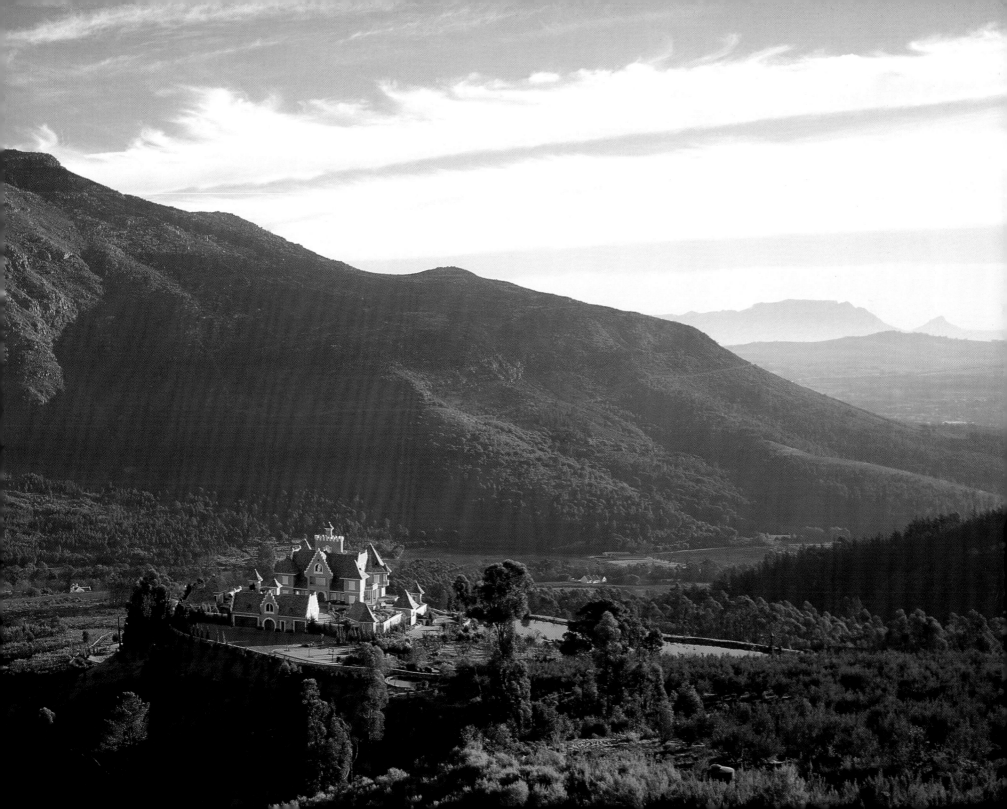

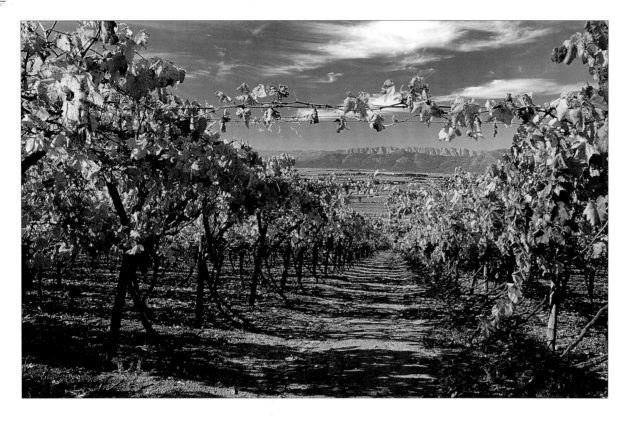

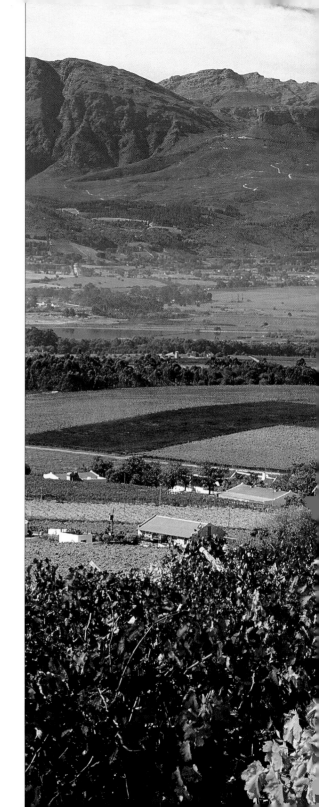

Above *Every year thousands of South Africans and visitors from abroad flock to the winelands to explore the age-old art of viticulture, sample the fine wines and visit the cellars and distilleries of local wine- and brandymakers.*
Left *The vineyards of the Boland lie at the heart of South Africa's wine-producing land, and the farms, estates and co-operatives of the region produce excellent wines.*
Right *The wine country of the Paarl Valley is backed by the Klein Drakenstein Mountains.*

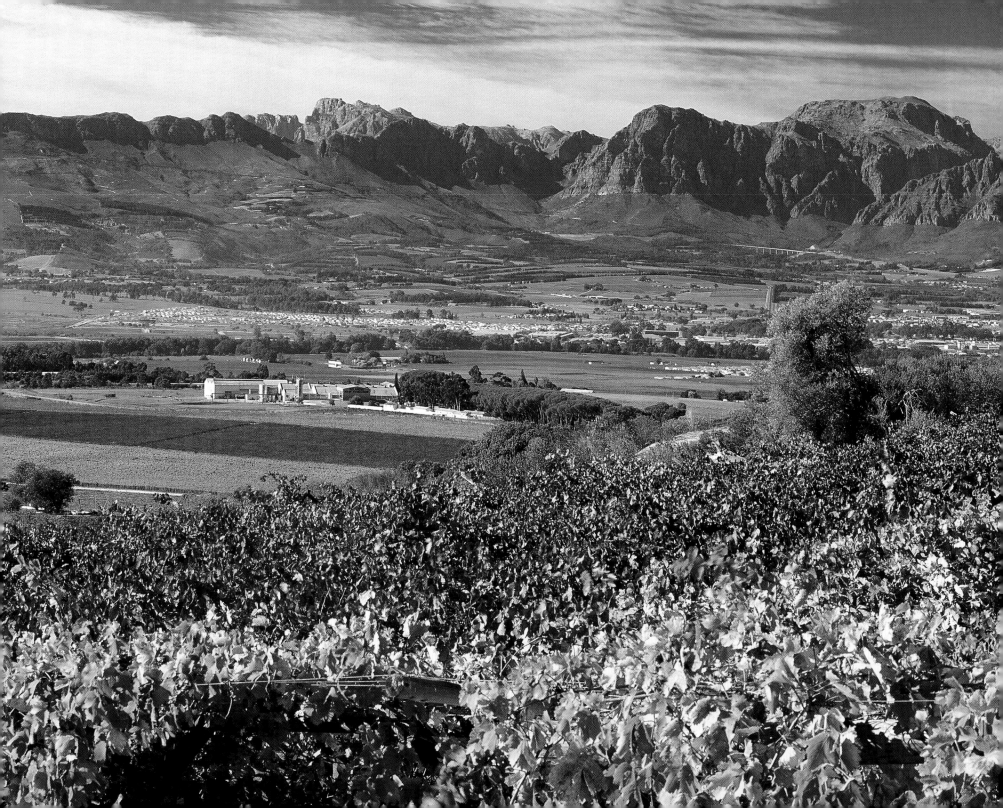

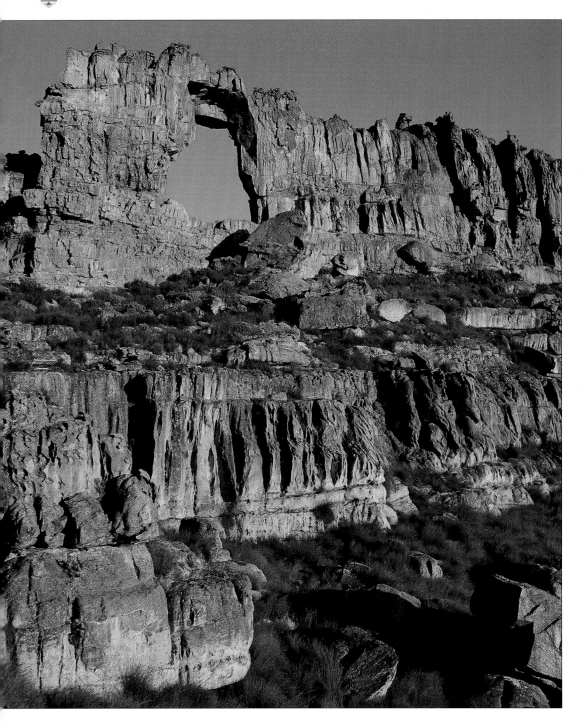

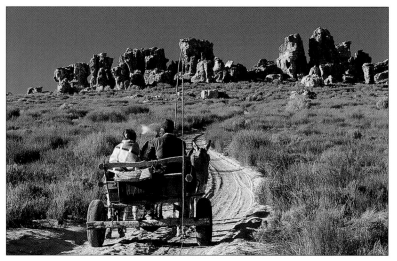

Left The monumental Wolfberg Arch is the pride of the Cederberg's primitive landscape, and the conservation of this wilderness remains a priority.
Top Many of the local villagers in and around the Cederberg continue to live a life distant from modern trappings of the twentieth century.
Above One of the many attractions of the rugged West Coast is its bird life, most notably waterbirds such as gulls, flamingos, pelicans and gannets.
Opposite Fishing boats continue to ply the waters off Lambert's Bay for its plentiful harvest, while flocks of gulls and gannets watch over fishermen's villages.

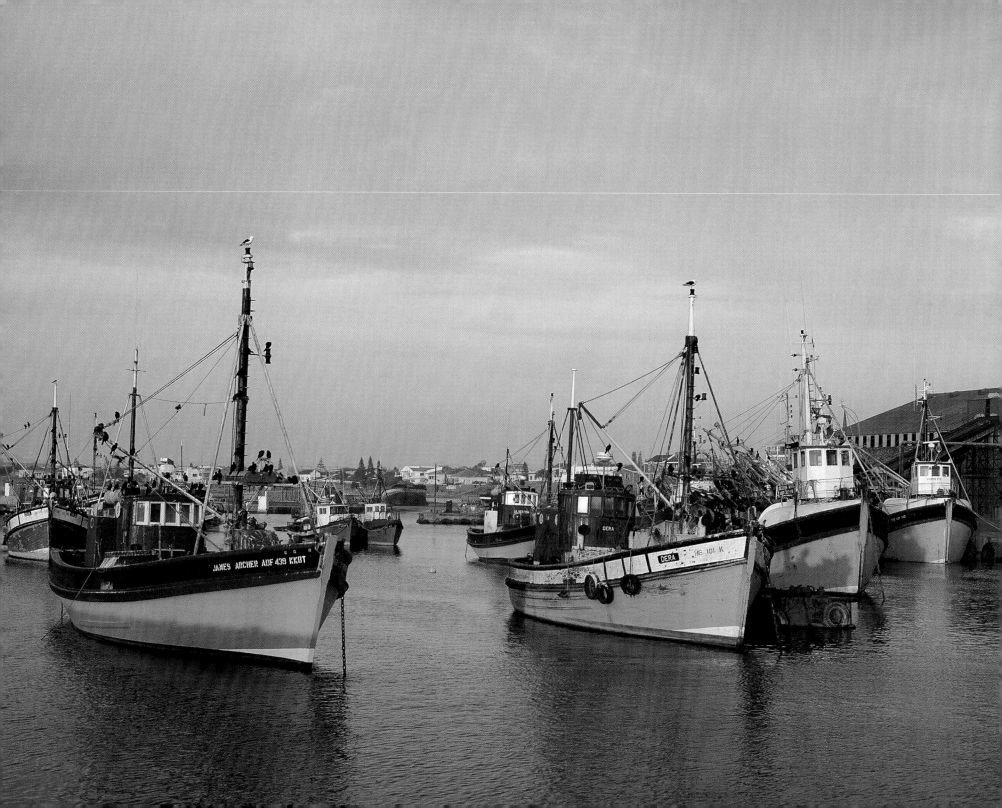

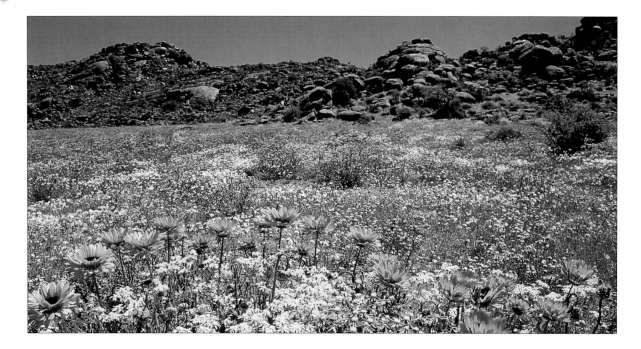

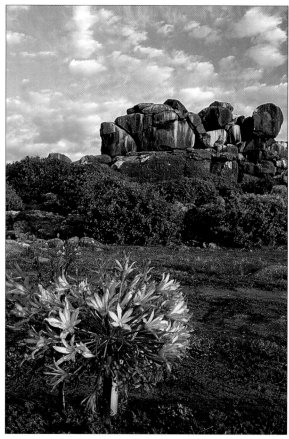

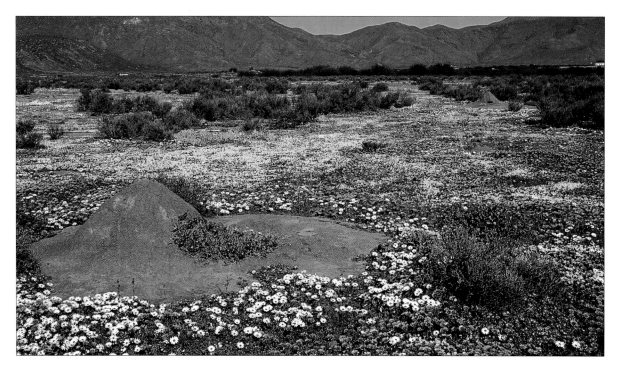

Top left *As spring dawns over the Goegab Nature Reserve near Springbok, its long-dormant veld suddenly explodes into fields of colour.*

Left and above *Despite the often desert-like landscape of Vanrhynsdorp's pebble-strewn hills, spring sees the fine blooms of vygies and indigenous annuals.*

Opposite *Sometimes a riot of colour and sometimes entirely desolate, the open veld of the Goegab Nature Reserve is one of the most significant of the area's wildlife preserves.*

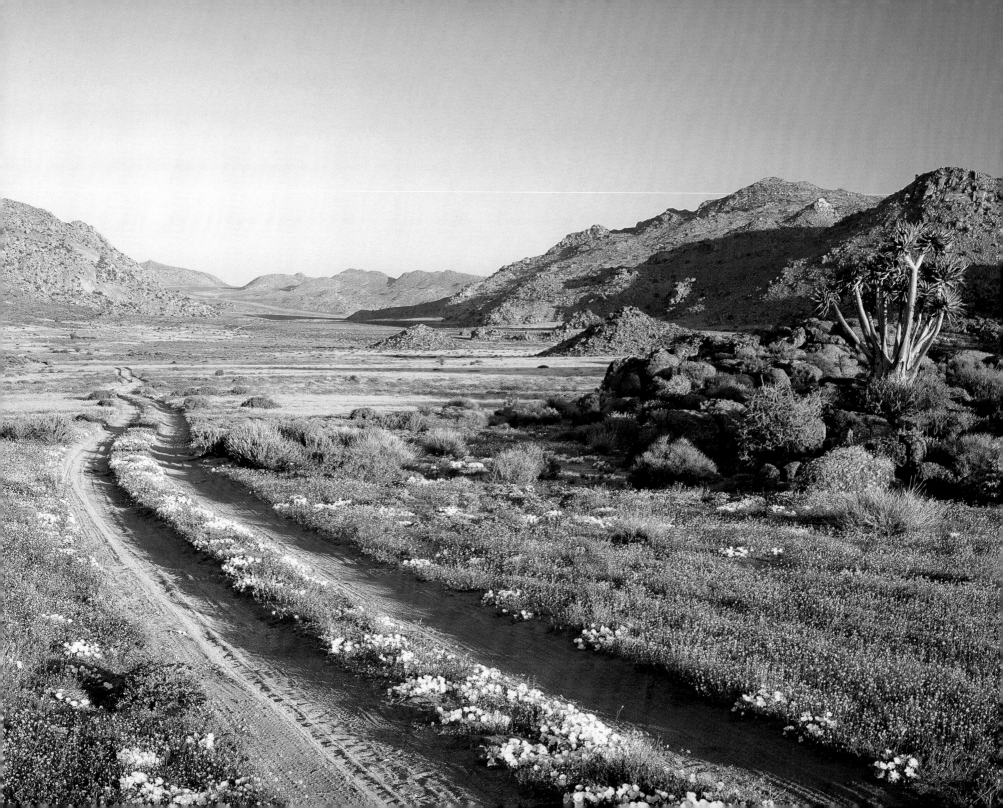

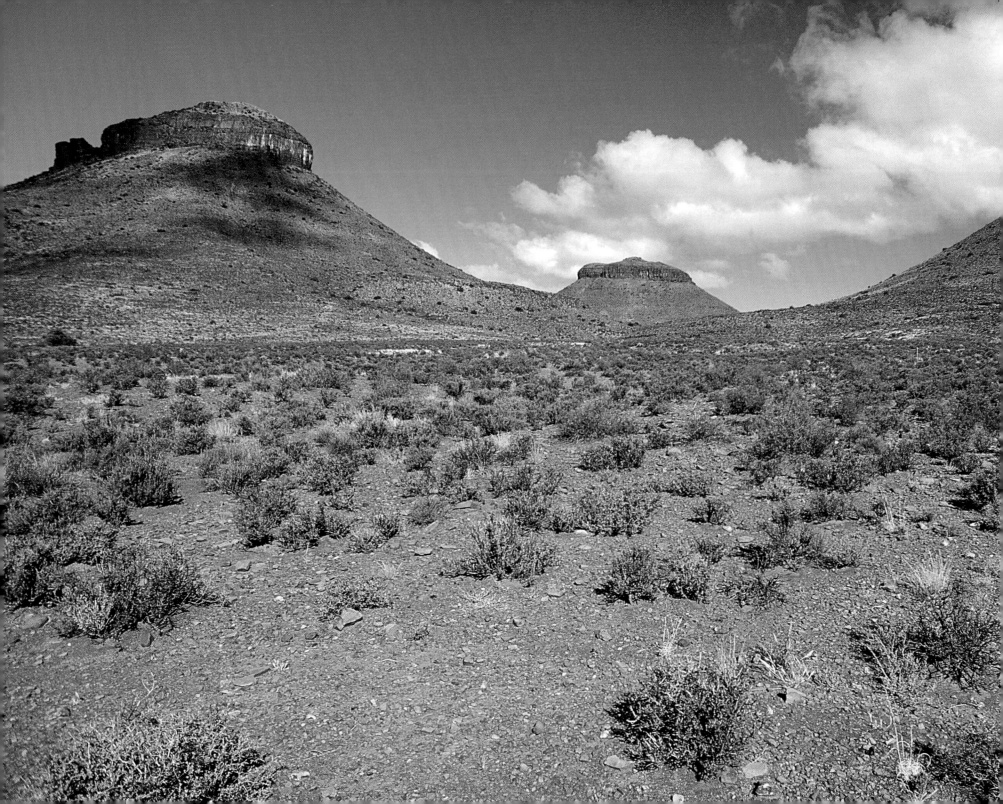

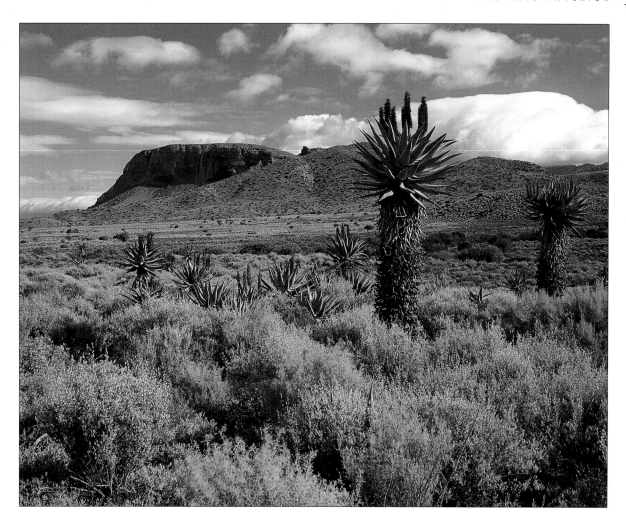

Left *The desolate expanse of the Great Karoo is punctuated with the imposing buttresses of the Three Sisters, watching forlornly over the shrub-covered veld.*

Above *After the dry Great Karoo, the life-giving rivers and streams of the Little Karoo provide an oasis of cultivated lands and plantations.*

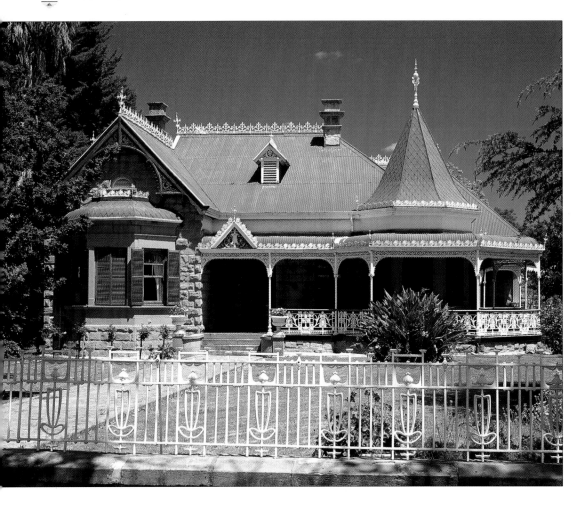

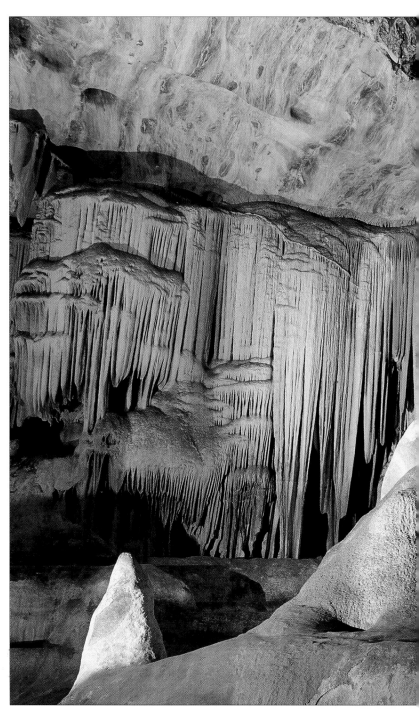

Above At the centre of the Little Karoo lies the 'ostrich kingdom' of Oudtshoorn, a charming old town punctuated with monuments and museums, but best known for its gracious Feather Palaces, such as Mimosa Lodge, built during the nineteenth-century boom in the feather industry.
Right and far right The series of ghostly chambers of the Cango Caves winding through the Swartberg was etched from the rock over thousands of years, and tens of thousands of visitors flock to marvel at the Throne Room of Botha's Hall and the other wonders of this natural phenomenon.

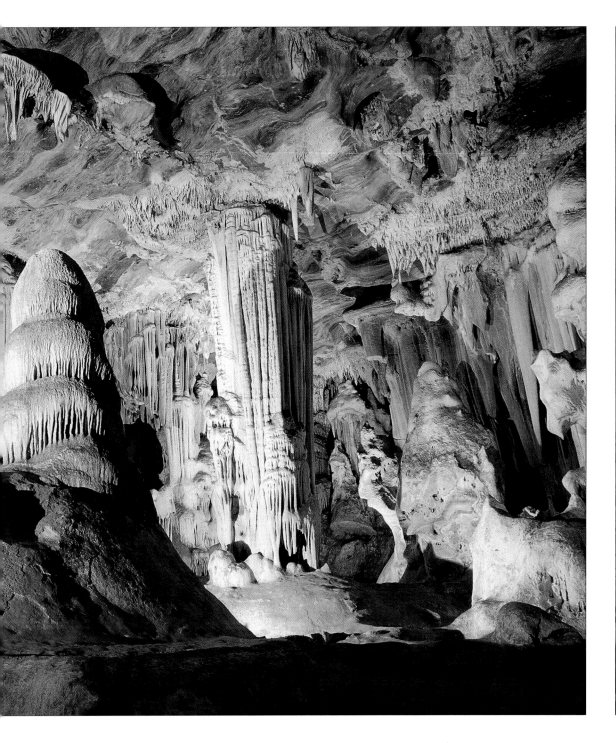

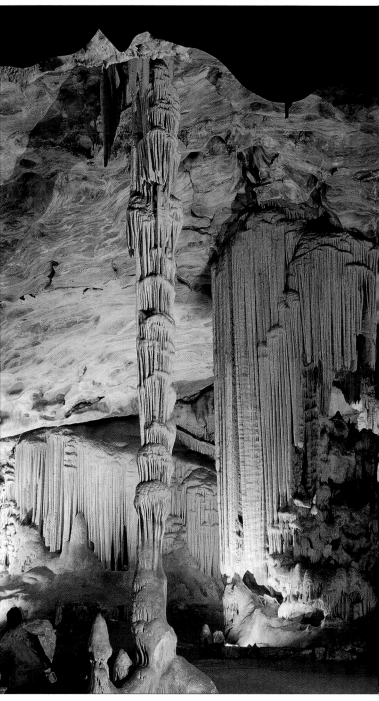

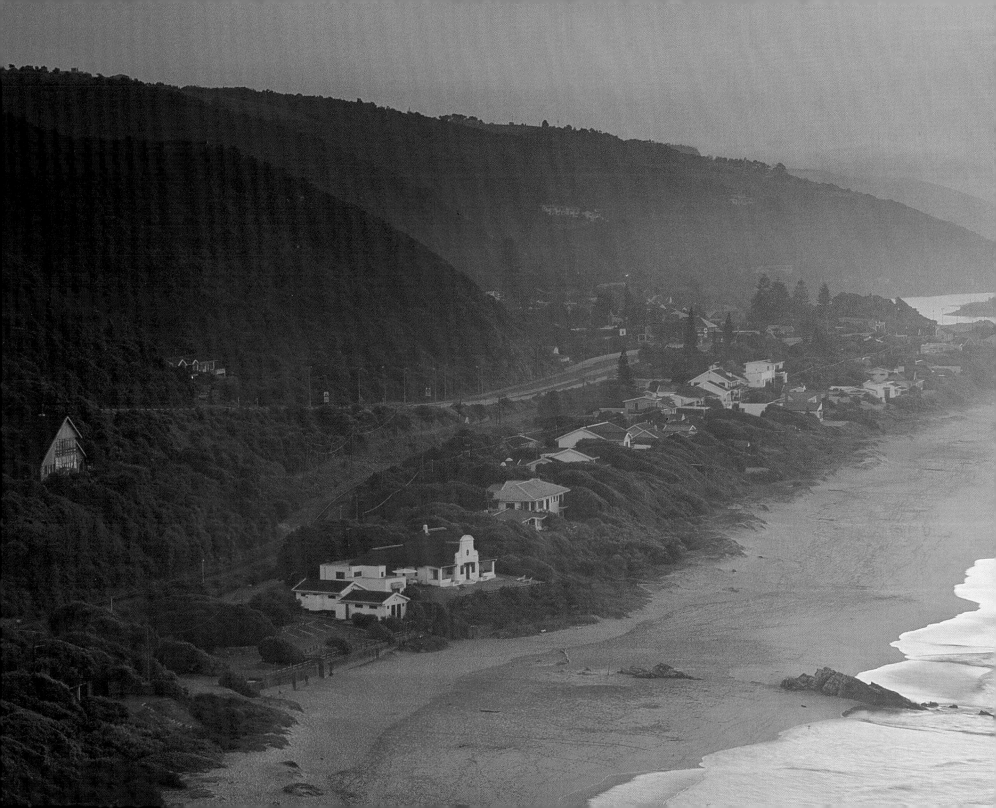

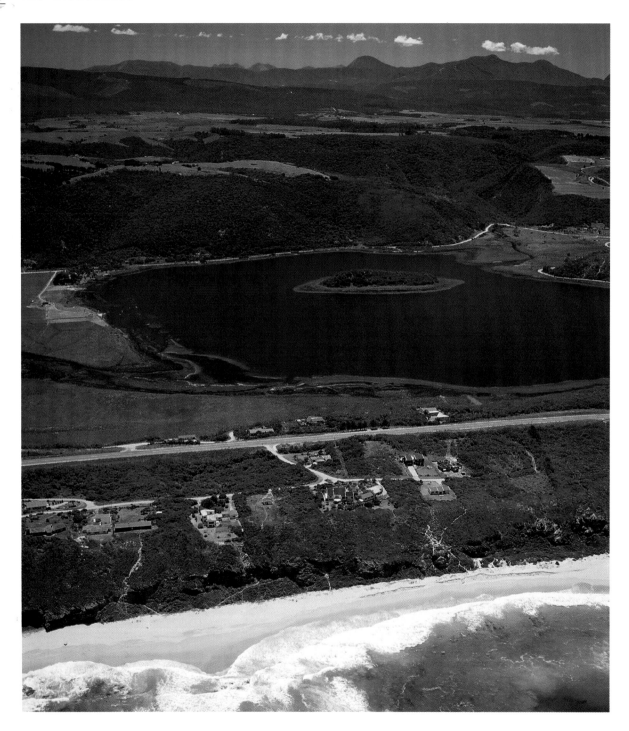

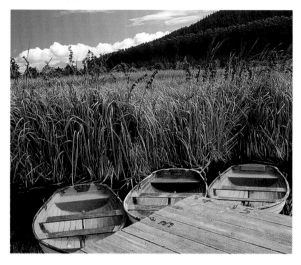

Previous page *Viewed from Dolphin Point, the southern Cape sun rises over a misty Wilderness.*
Left *The Wilderness Lakes Area is laced with the waters of the Wilderness Lagoon, the Touws River estuary, Rondevlei, Swartvlei and part of the fishing paradise of Groenvlei.*
Above *Also known as Lake Pleasant, the bountiful waters of Groenvlei remains a haven for fishermen and anglers.*
Opposite *The Outeniqua Choo Tjoe, a century-old locomotive steam engine running between George and Knysna, crosses the expansive gorge spanned by the Kaaimans River Bridge.*

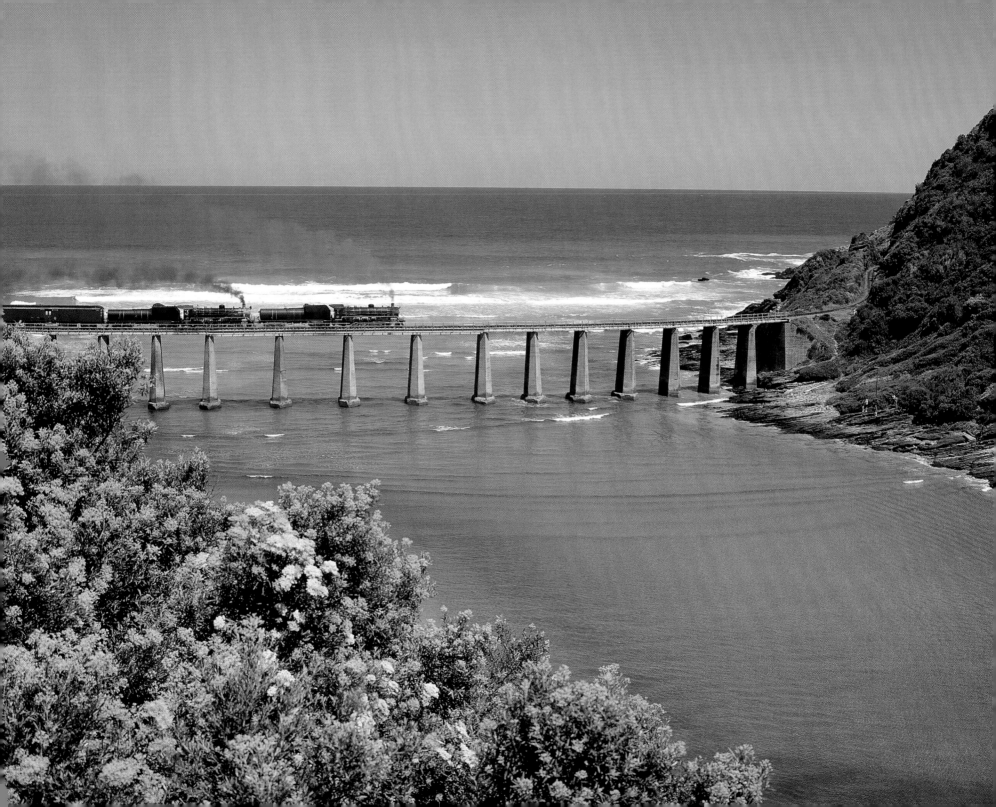

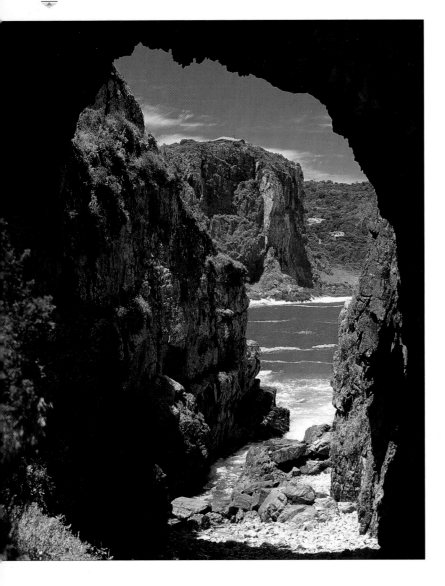

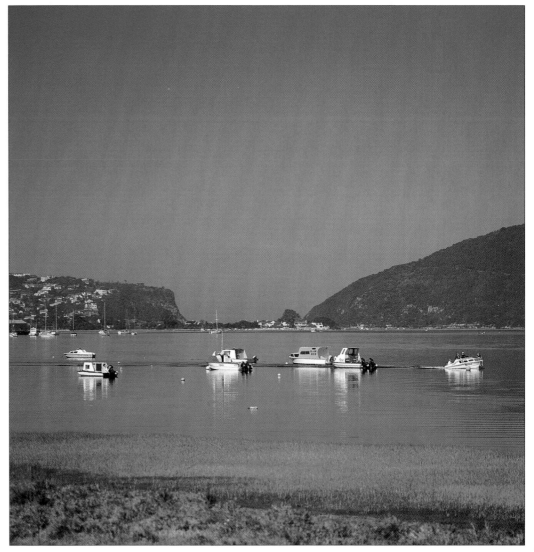

Above *Accessed only via the Featherbed Ferry or by private boat, the Featherbed Nature Reserve sprawls across the slopes of the Heads on the western side of Knysna Lagoon.*

Above and opposite *Guarded by the Knysna Heads and protected by ever-watchful conservationists, Knysna Lagoon is a natural sanctuary for the area's wildlife.*

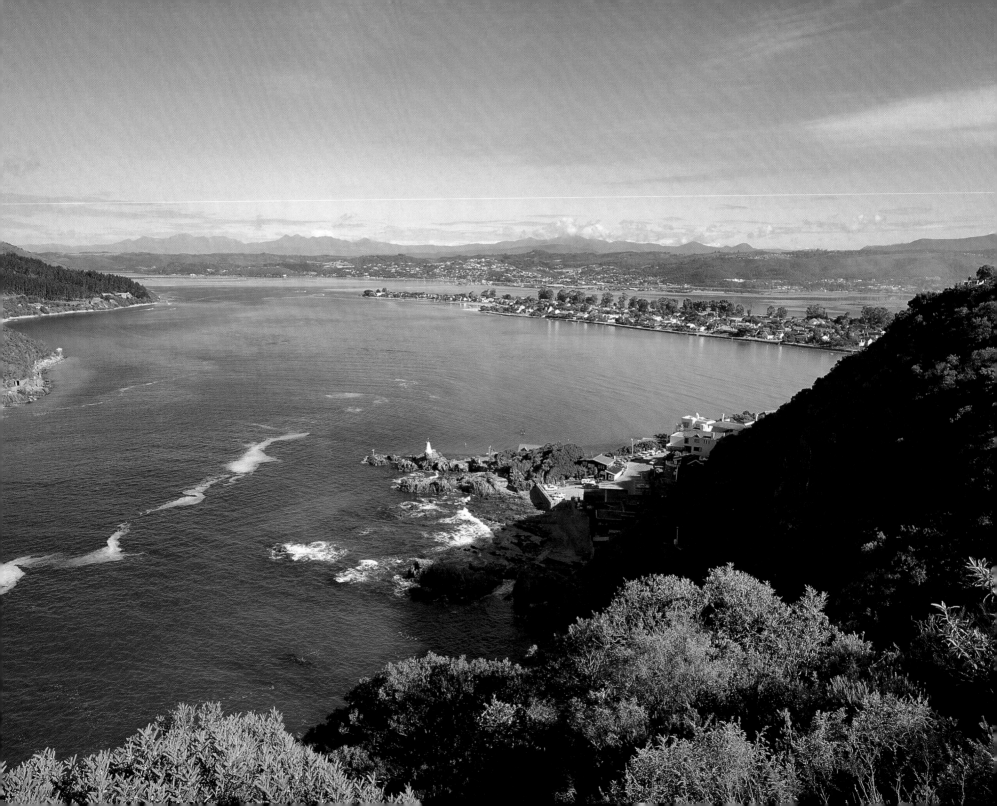

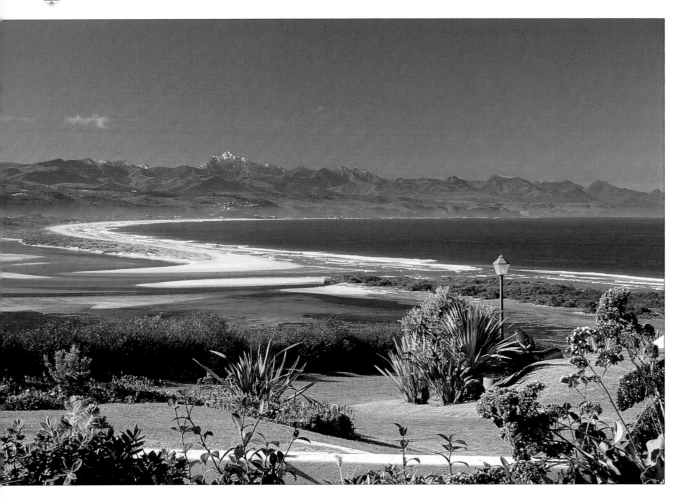

Above *Stretching north up Lookout Beach, the lagoon and snow-capped mountains of winter that skirt Plettenberg Bay attract horse riders, canoeists, hikers, and other naturalists.*
Right *Playful and colourful, Plettenberg Bay is one of the country's favourite seaside resort towns and the Beacon Isle Hotel and Hobie Beach are popular holiday haunts.*

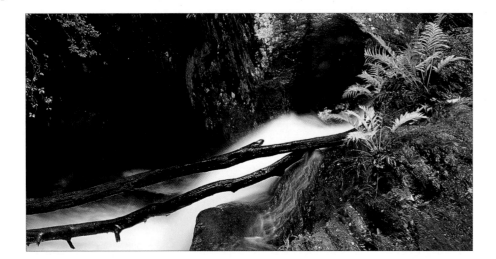

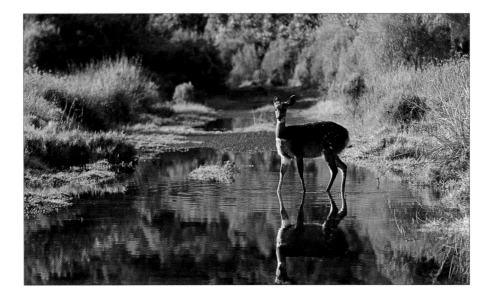

Top left *The land and marine conservation locales in the immediate vicinity make the tranquil Tsitsikamma area a much-favoured natural retreat.*

Above left *A watchful bushbuck, reflecting the tranquility of the Tsitsikamma forest, stands alone in Nature's Valley, a peaceful little reserve at the foot of the Groot River Pass.*

Above right *Towered over by the Bloukrans Pass, the Tsitsikamma is a haven of yellowwoods, orchids and lilies, among which live baboon, duiker, and Cape clawless otters.*

Opposite *The Tsitsikamma Coastal National Park at Storm's River Mouth stretches for 80 kilometres and includes a marine reserve – the winter home of dolphins and whales.*

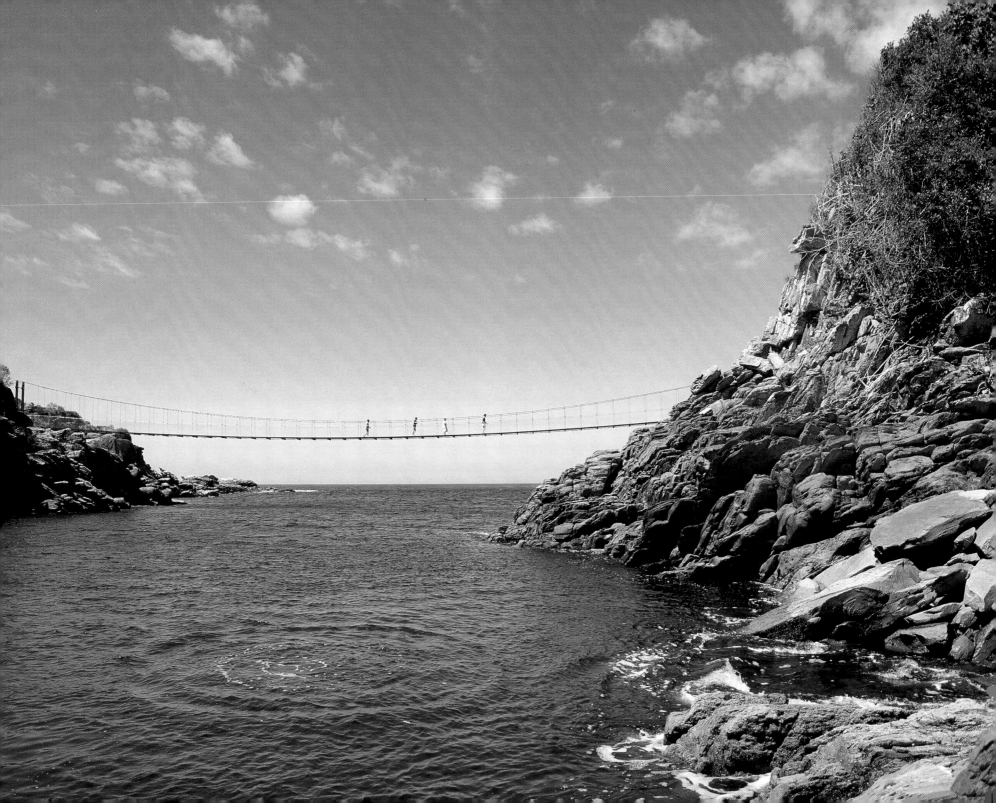

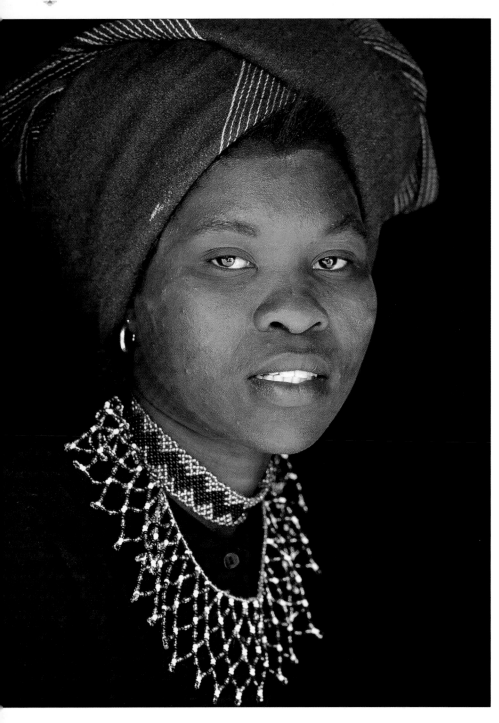

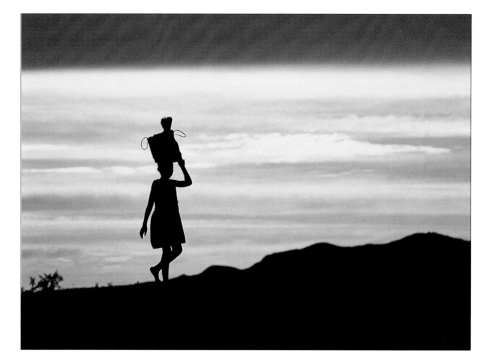

Left *The Eastern Cape is the traditional home of this Xhosa woman and her people, and the clicking sounds of their lively native tongue are constantly heard across farmlands, on street corners and in family kraals.*
Above *Returning to her kraal at dusk, a Xhosa maiden crosses a land all too regularly plagued by debilitating drought.*

Opposite *Skirted by the green countryside of the Eastern Cape, the Hole in the Wall on this wild and rocky coast has been sculpted by the many centuries of weathering action of both wind and water.*

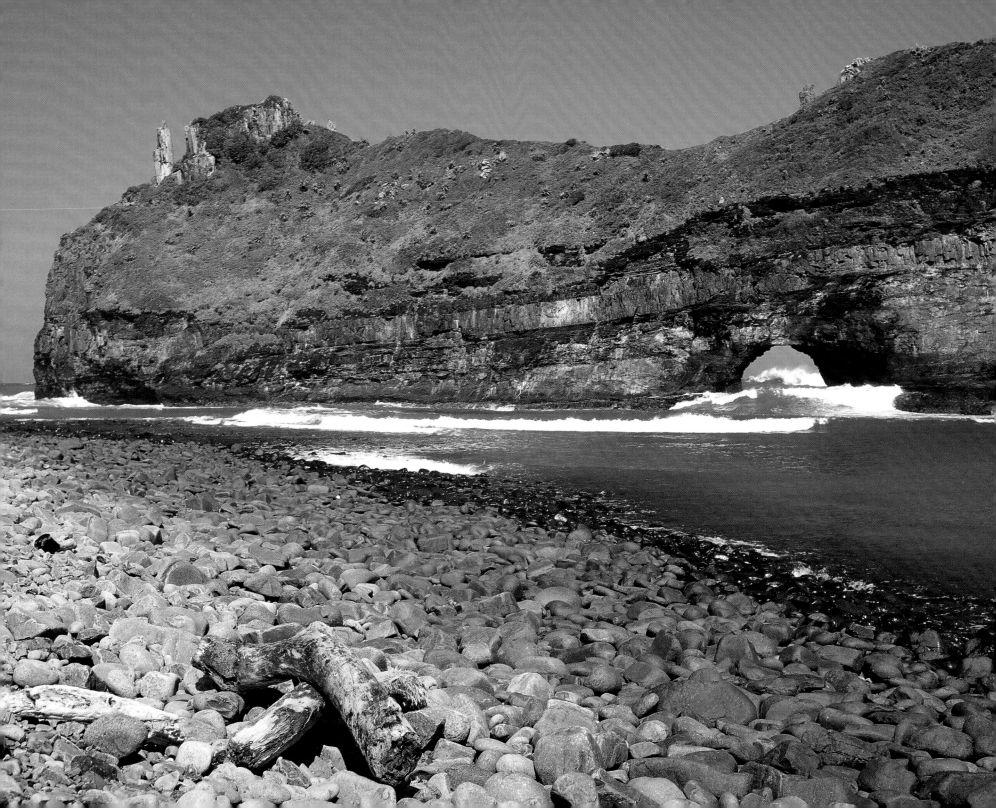

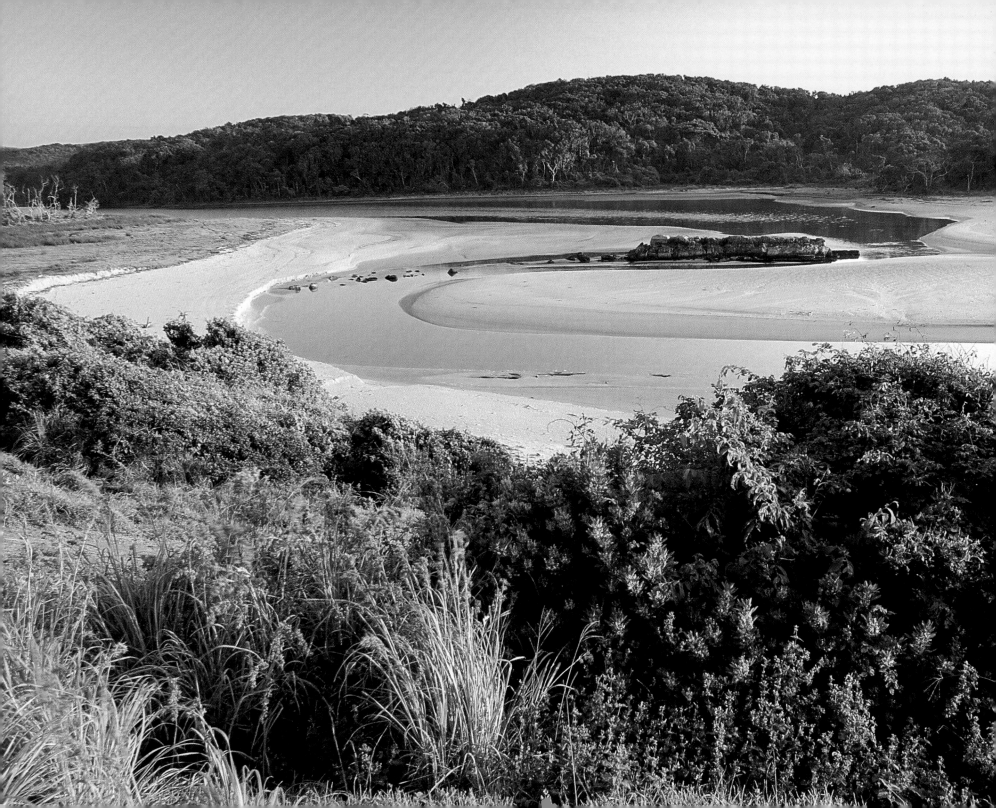

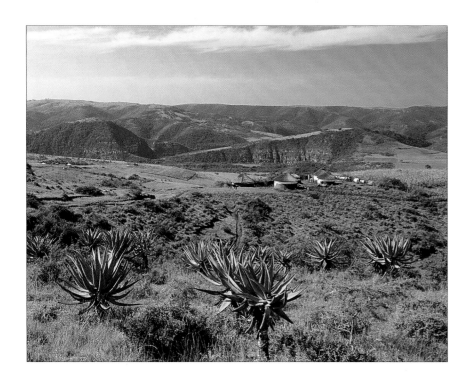

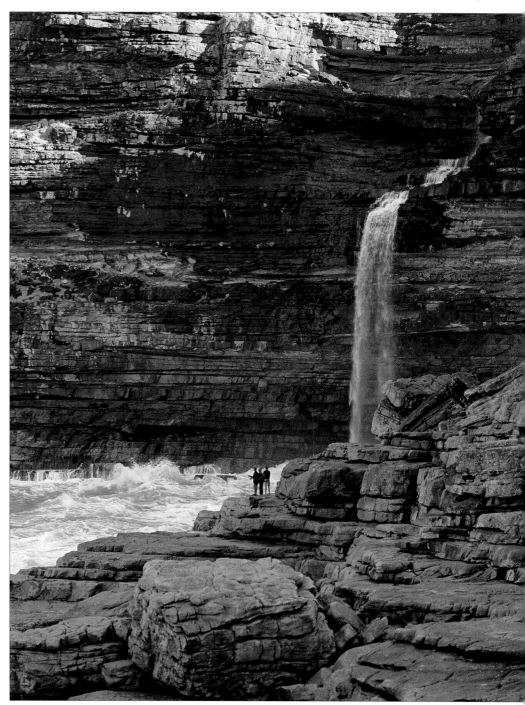

Opposite *The winding Mbashe River empties into the great Indian Ocean at a point near Bashee between Umtata and Port Elizabeth on the Wild Coast.*
Above *Many tribal homesteads such as this Xhosa village amid the aloes near Elliotdale remain true to their cultural heritage: women tend the home and lands, while the menfolk earn the family's keep.*

Right *Following a course roughly hewn from the surrounding rocks, the tumbling waters of the Mzintlava River fall at the Wild Coast's Waterfall Bluff.*

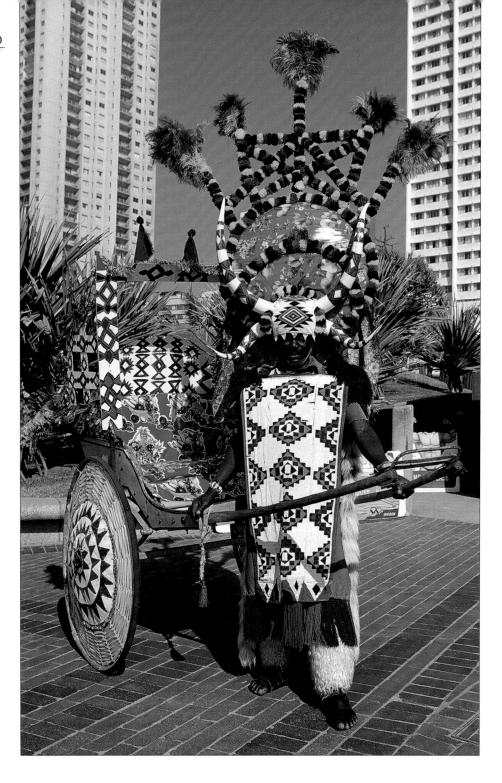

Left *Although the coulourful rickshaws originated in the Far East in the era of horse-drawn carts, traditional Zulu rickshaw pullers have added their own trimmings and accessories, and remain a tourist attraction on Durban's streets.*

Above *Durban, the country's leisure capital, is much favoured during peak summer season, when Marine Parade and the beaches along the six-kilometre Golden Mile are covered with holiday-makers soaking up the sun.*

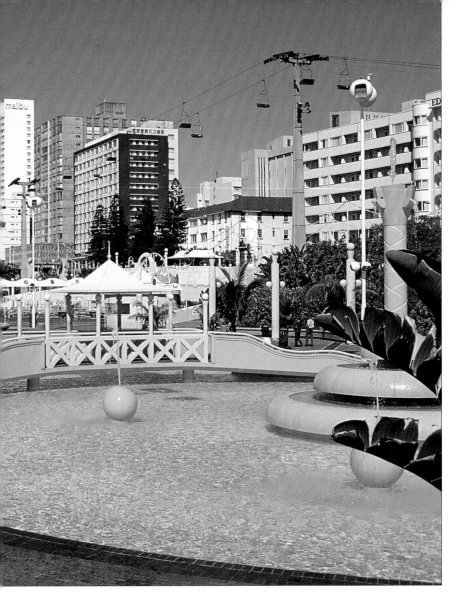

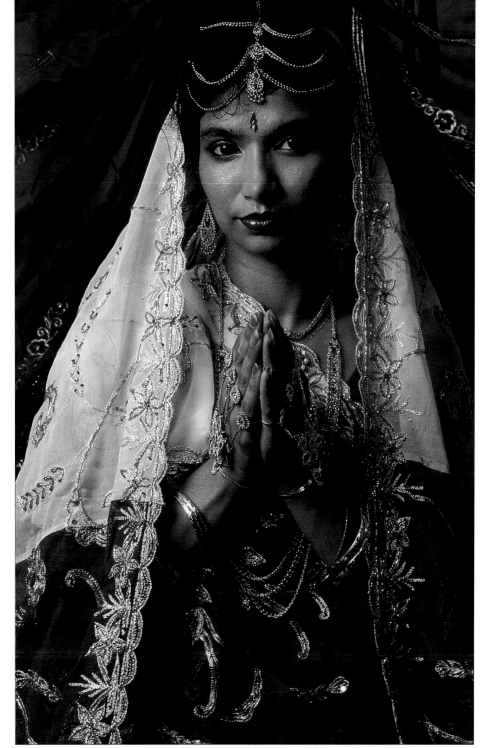

Far right *A Hindu bride captures Durban's Indian heritage, influencing as it does the city's cultural elements.*
Overleaf left *As a top leisure centre, small pleasure craft still crowd the moorings at Durban's Victoria Embankment.*

Overleaf right *The Durban cityscape is dotted with reminders of its cultural diversity, but nowhere is this more evident than when trek fishermen prepare to embark from Addington beach for a day out on the Indian Ocean.*

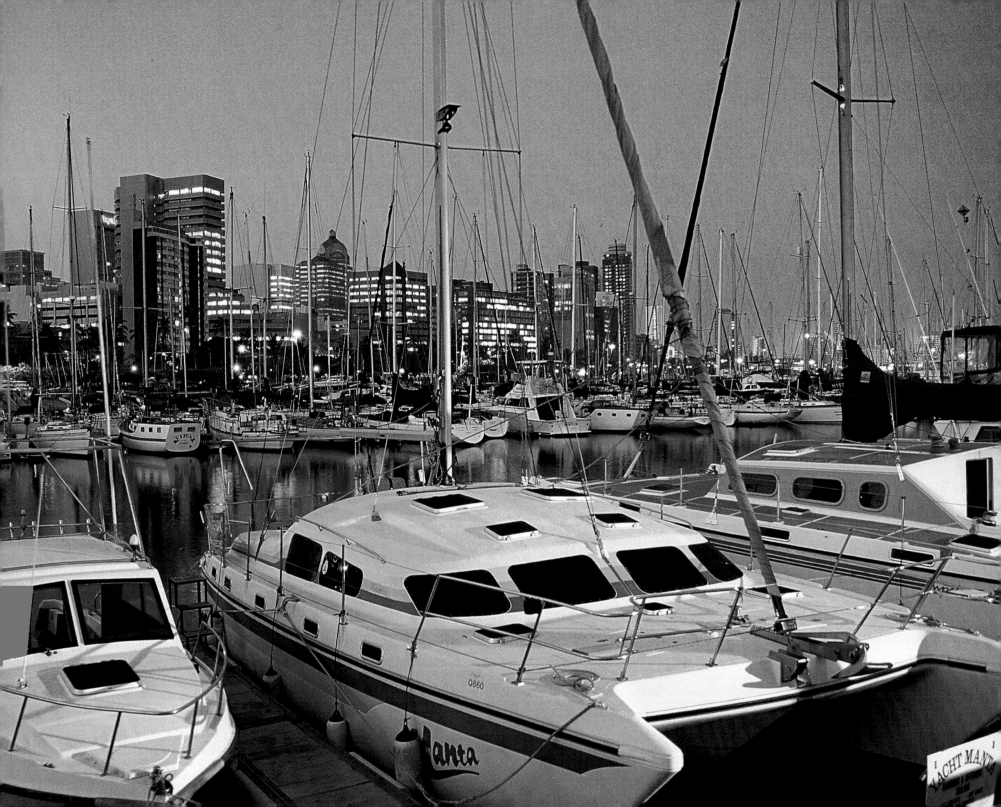

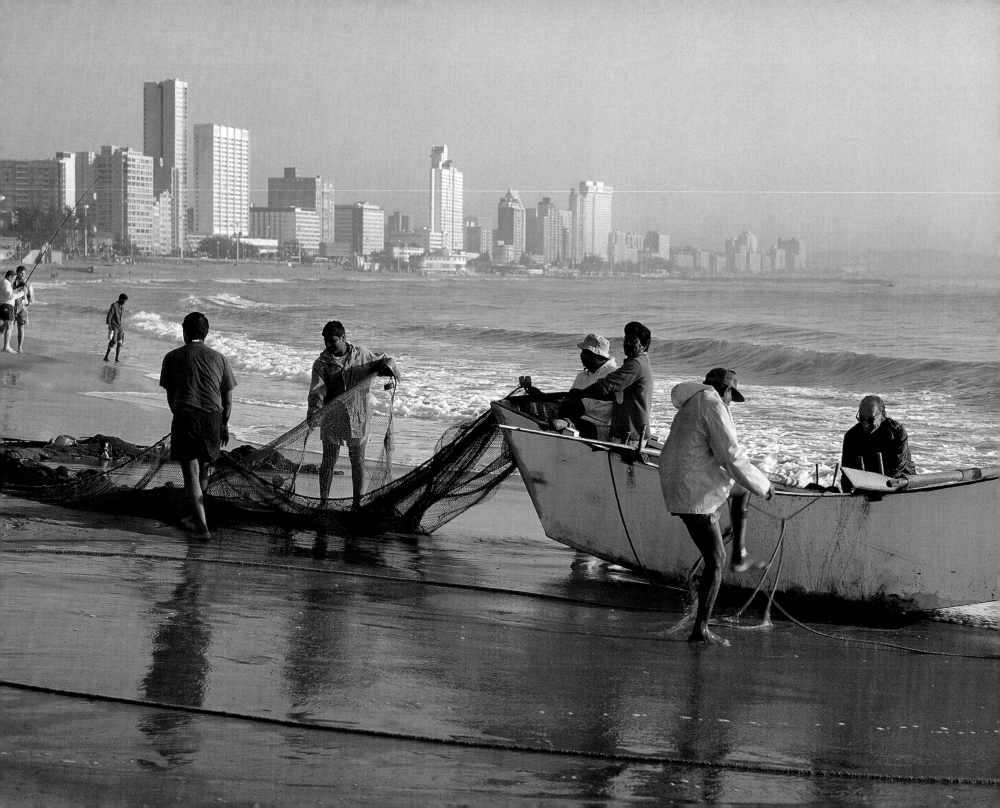

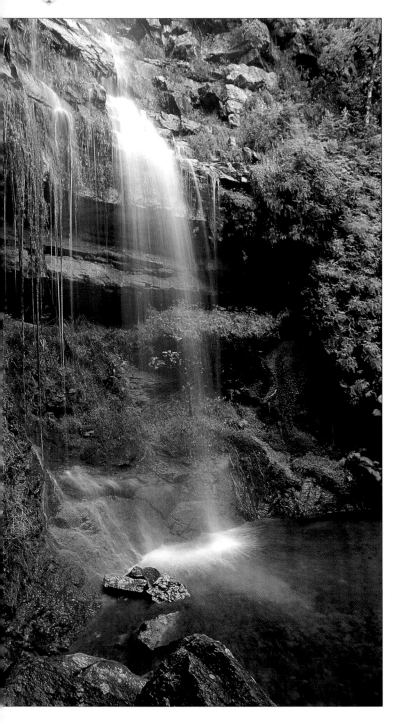

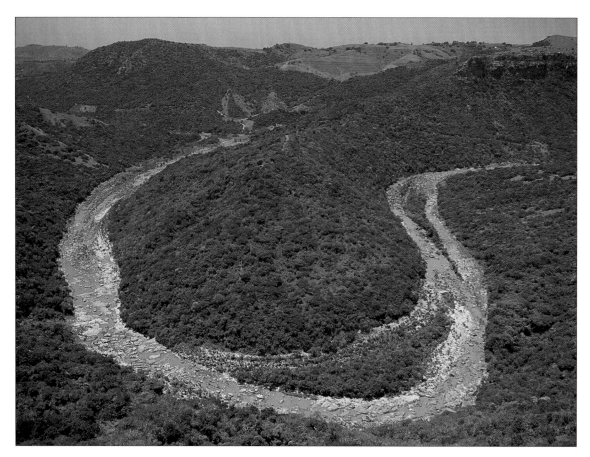

Left *Cascading down the rugged rockface in the Oribi Gorge Nature Reserve near Port Shepstone are the Samango Falls, one of KwaZulu-Natal's impressive but lesser-known natural wonders.*

Above *The sandstone cliffs of Oribi Gorge have been carved from the land by the rushing water of the Umzimkulwana River on its dramatic route to the ocean.*

Opposite *The beach and hotels of Umhlanga on Durban's north coast reign supreme as KwaZulu-Natal's premier holiday resort, and the frenetic holiday season sees a multitude of eager sun-seekers.*

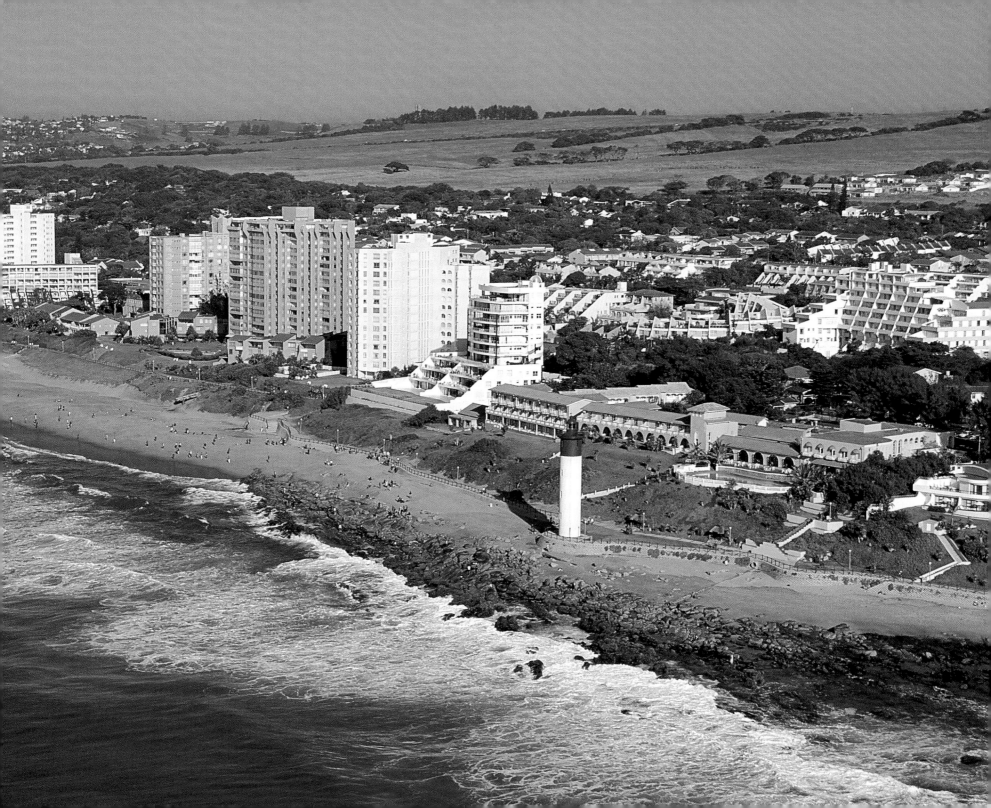

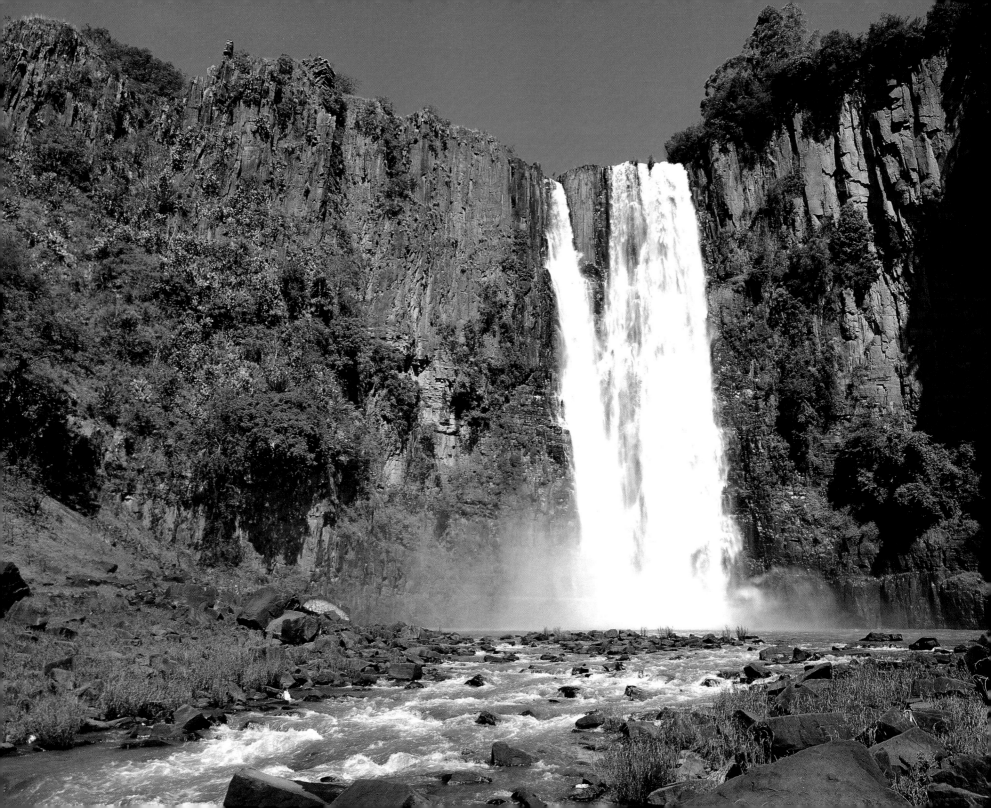

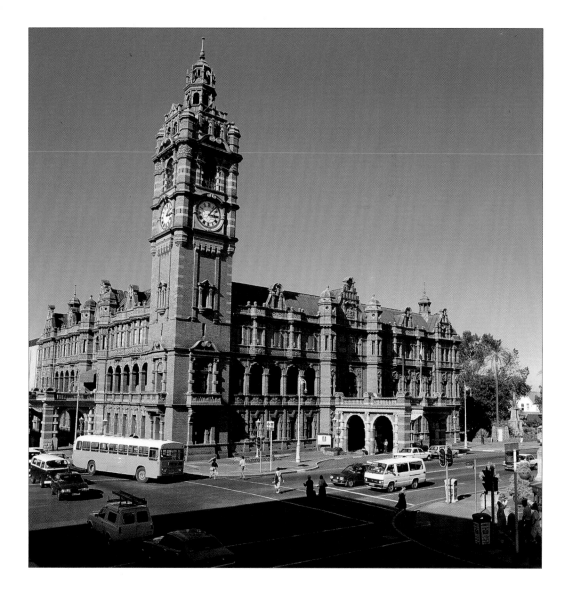

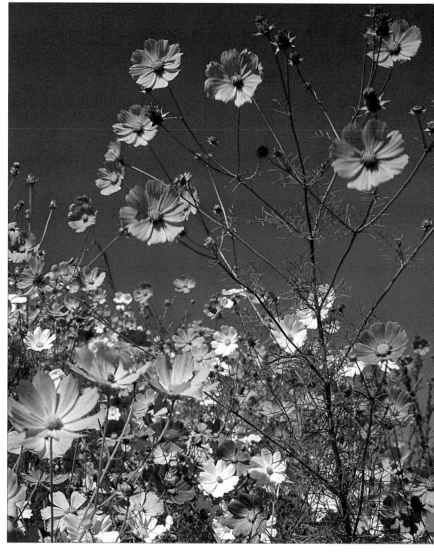

Opposite *On the northern bank of the Mgeni River in the KwaZulu-Natal Midlands, the spectacular 95-metre Howick Falls is known locally as 'place of the tall one'.*
Above *Pietermaritzburg's streets are lined with grand old edifices such as the red-brick City Hall completed in 1893.*

Above right *A colourful display of wild cosmos fills the countryside of KwaZulu-Natal*
Overleaf left *Considering the legacy of flourishing fields of sugar cane, it is little wonder that the Zulus called the rolling landscape Umzinto, meaning 'place of achievement'.*

Overleaf right *Rich in both wildlife and many species of indigenous flora, the view from Botha's Hill extends right across the lush landscape which was so aptly named by the local Zulus as the Valley of a Thousand Hills in the rolling midlands of KwaZulu-Natal.*

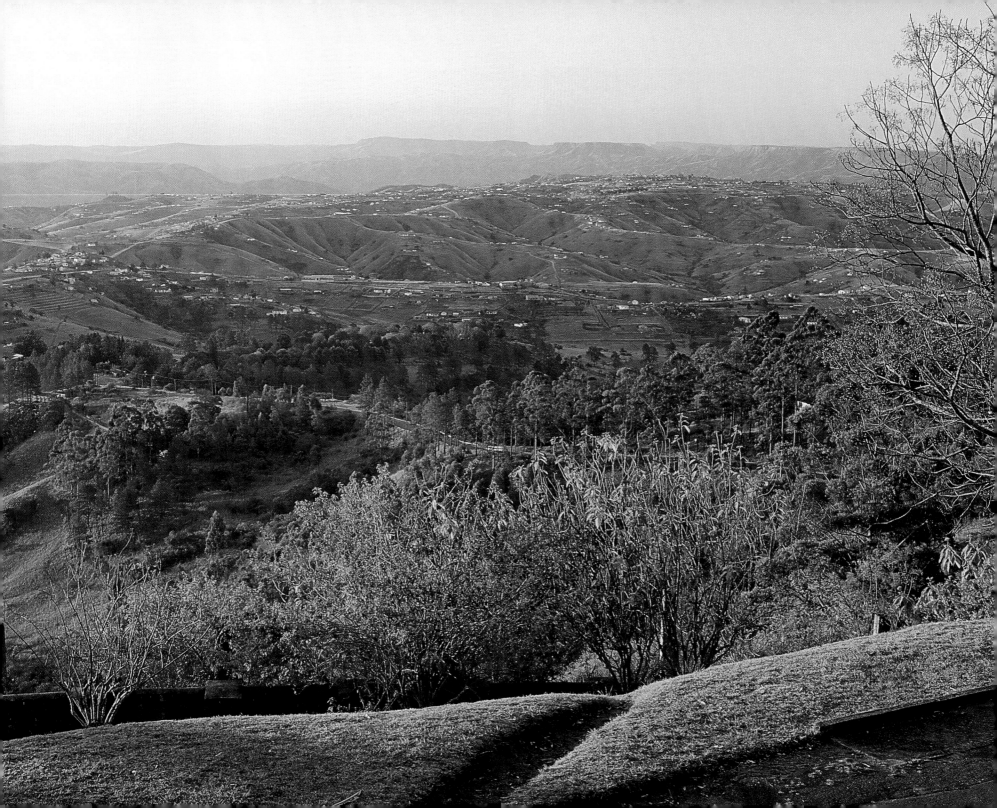

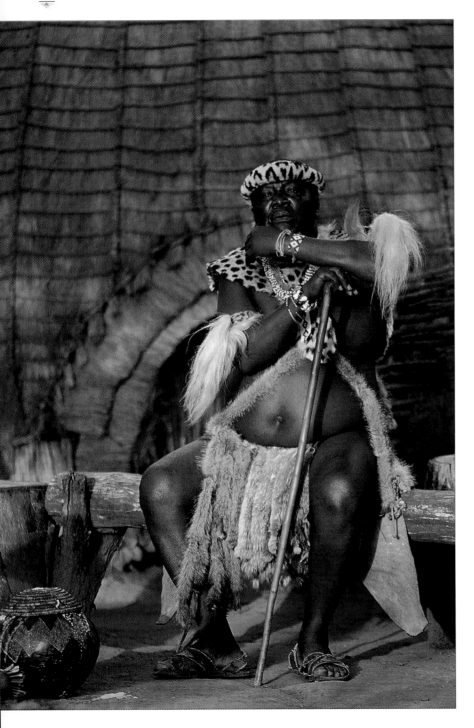

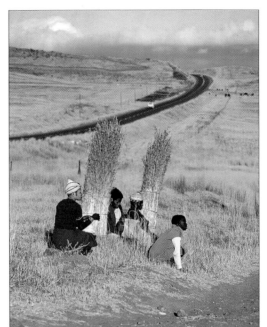

Left *Traditionally led by a chief in regal leopard skin, the Zulu nation is steeped in a proud and often turbulent history, and continues to play an important role in the latter-day politics of the country.*

Above *Many of the rural Zulu communities like Nqutu rely on age-old customs, and the women continue to gather bundles of reeds which they will use to roof traditional kraals.*

Right *Bedecked in finely crafted beadwork, Zulu maidens or* intombi *at Shakaland offers visitors a look at tribal life in a traditional Zulu kraal.*

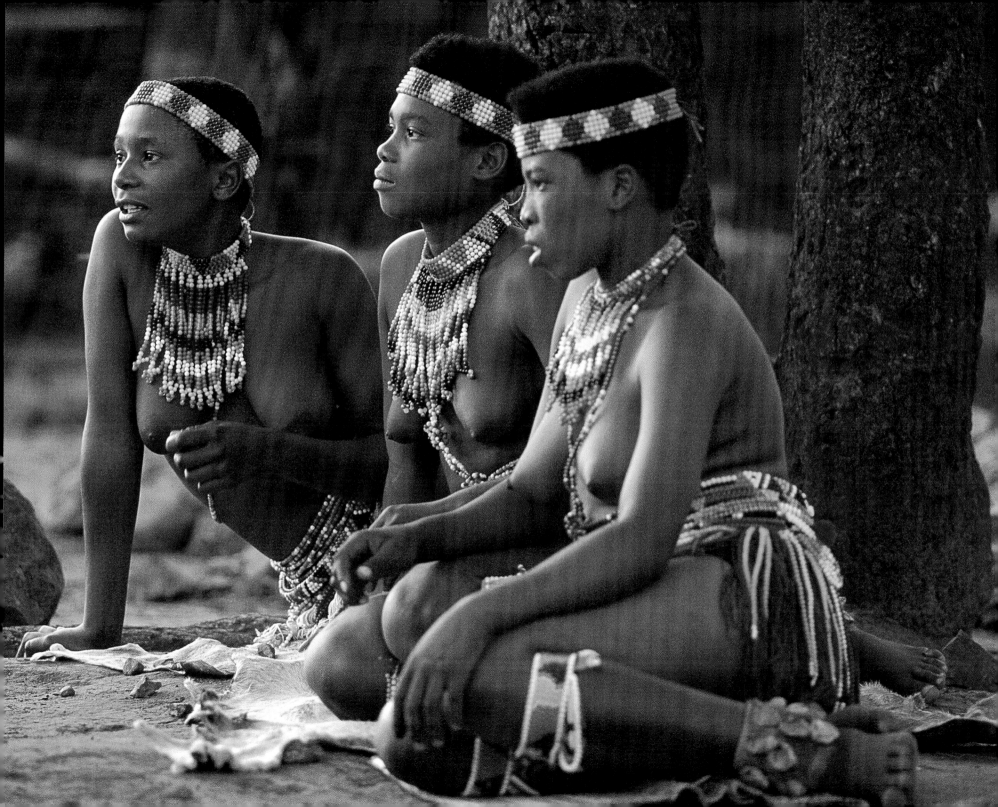

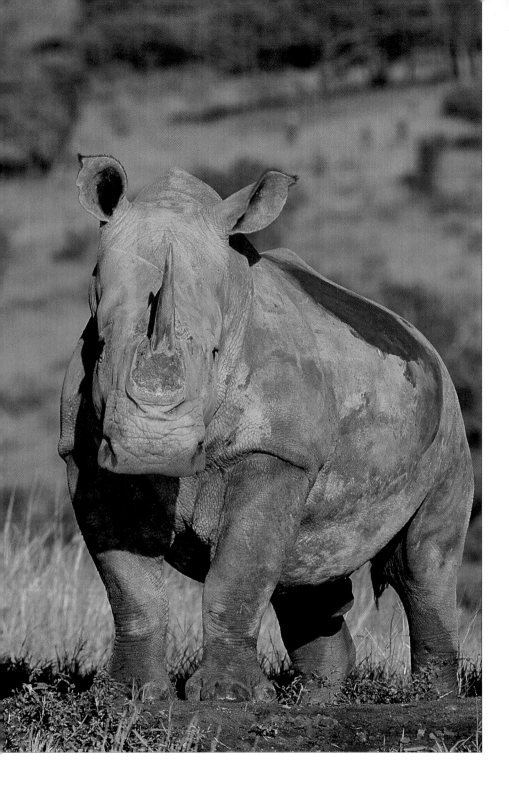

Left *Of the many vital conservation projects which have been initiated to preserve South Africa's natural resources, few can rival the success story of the Hluhluwe-Umfolozi Game Reserve's efforts to protect the white rhino from extinction.*

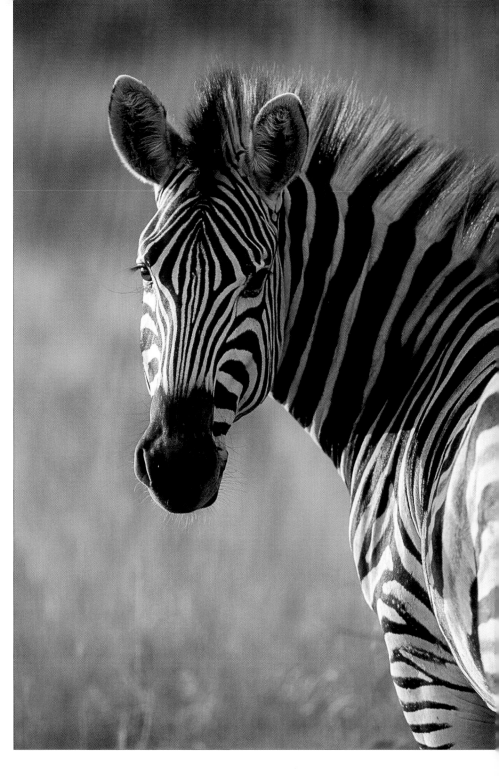

Above In an attempt to marry an African lifestyle with Western living, Simunye is a cross-cultural bush lodge located near Eshowe.

Right The characteristically patterned plains or Burchell's zebra may be seen in vast herds in the Hluhluwe-Umfolozi Game Reserve.

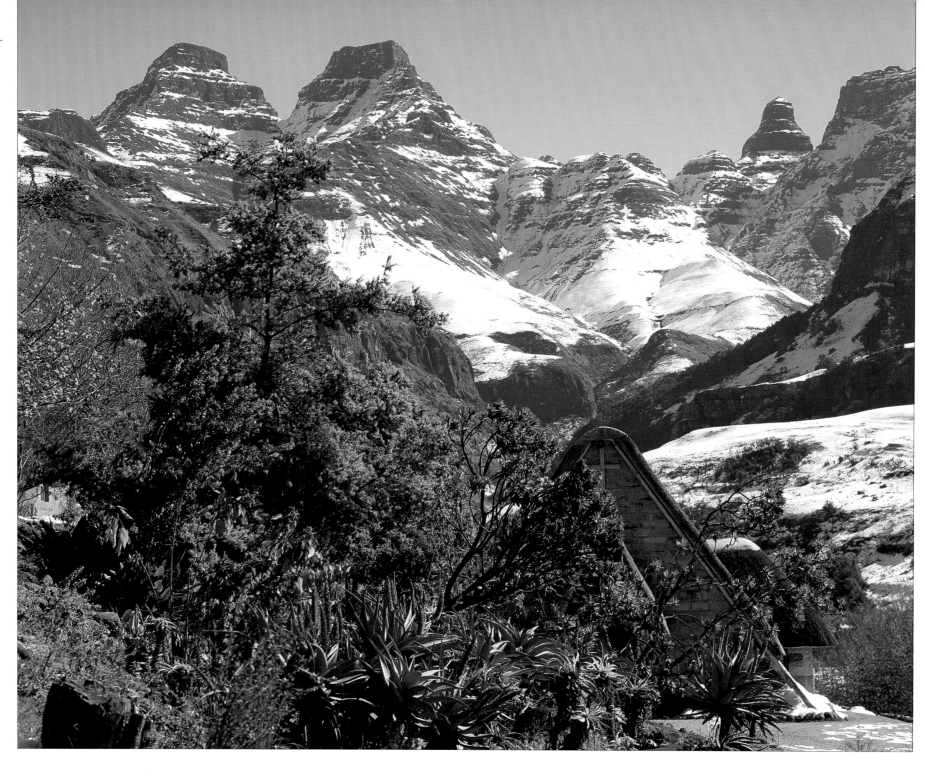

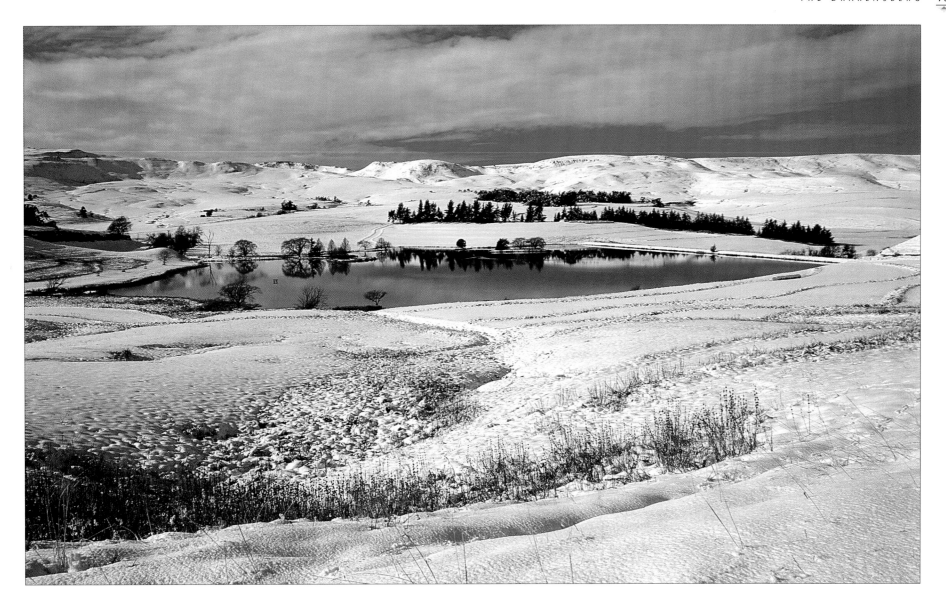

Opposite *The winter wonderland of the Drakensberg is indeed breathtaking, and few visitors to Cathedral Peak and its immediate surrounds can resist the spectacle of a landscape not usually associated with Africa.*

Above *Snow falls and ice forms on the boughs of the tallest trees and even the smallest plants which peek through the white blanket that covers the rural landscape near Nottingham Road in KwaZulu-Natal.*

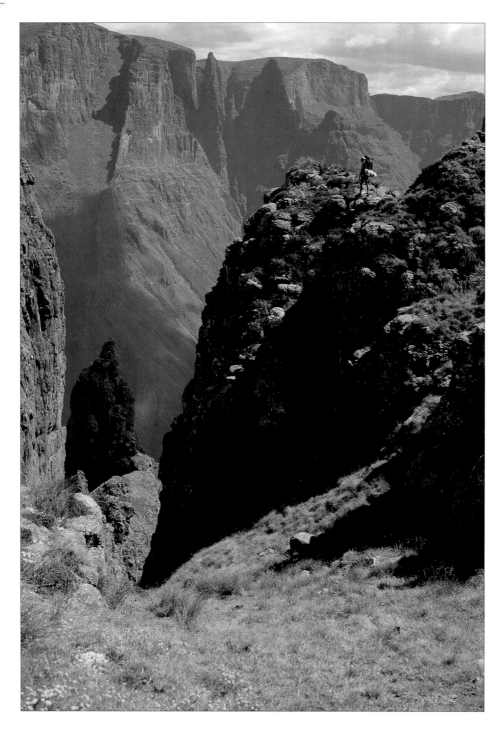

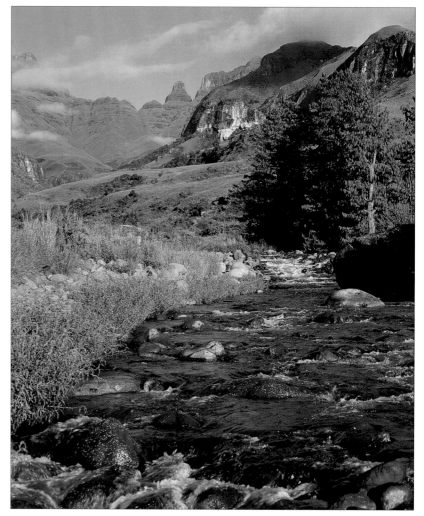

Left The gentle solitude of hikes and trails such as that at Mnweni Pass attract many naturalists to what local Zulus call the Barrier of Spears.
Above Often fed by the melting snow on the upper reaches of the high peaks, the Mlambonja River winds its way down the slopes of Cathedral Peak.

Opposite The hills of the Giant's Castle Game Reserve were once roamed by the San and the walls of local caves are still adorned with their rock art.

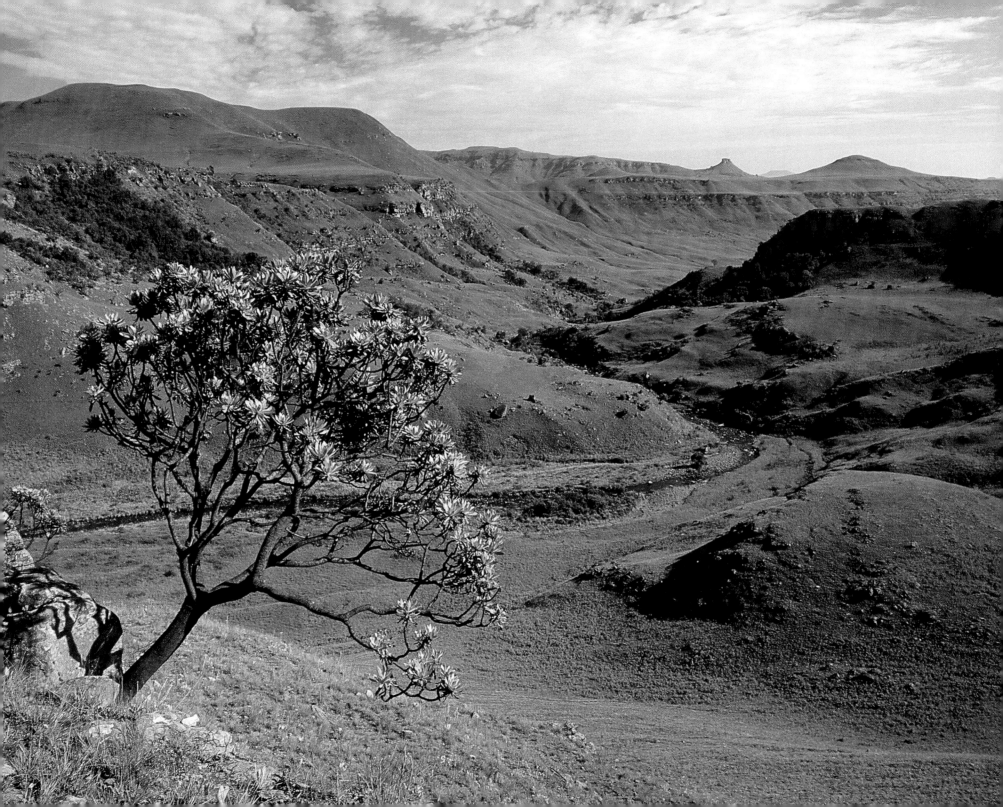

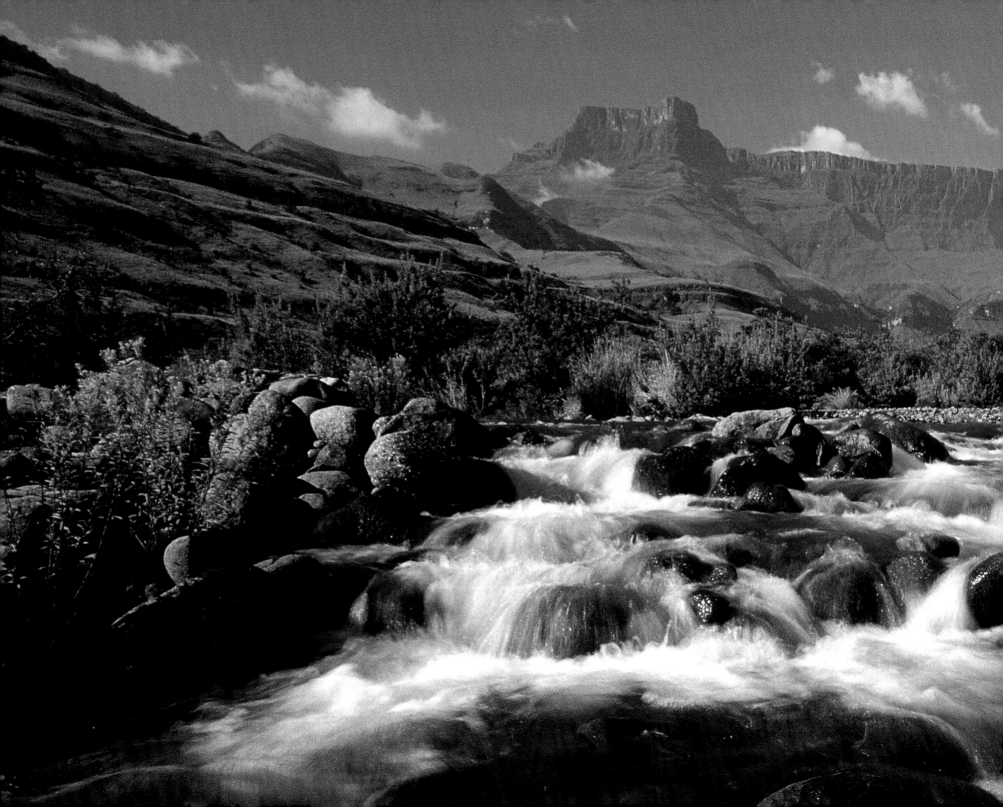

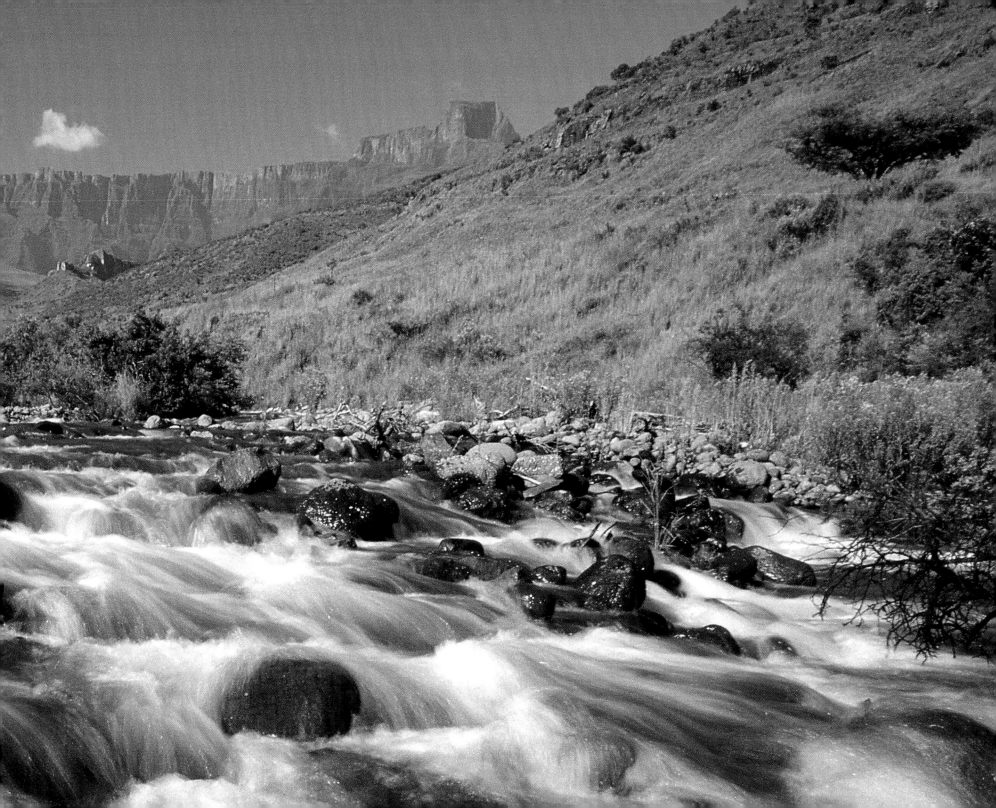

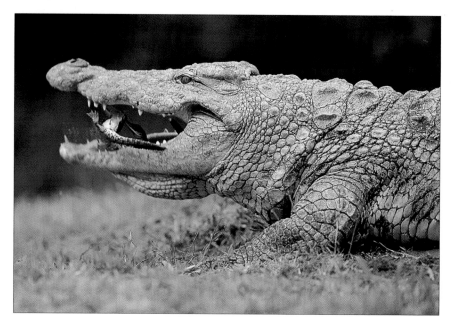

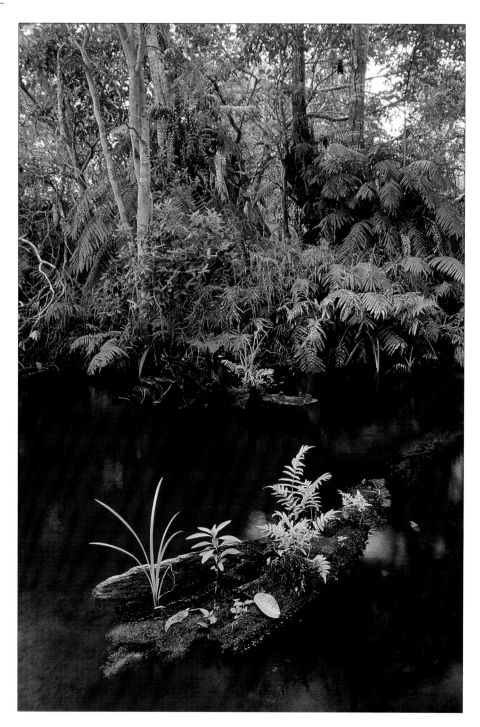

Previous pages *The towering Amphitheatre of the Mont-aux-Sources massif overshadows the Tugela River as it courses down the valley of the Royal Natal National Park toward the Indian Ocean.*

Left *The swamp forest along Mbazwana Channel in the northern reaches of the Greater St Lucia Wetland Park is overgrown with the ferns and undergrowth so distinctive of this sensitive wetlands area.*

Above and opposite *The waters and wildlife reserves of the Greater St Lucia Wetland Park are home to unique fauna and flora species and, in an effort to protect the crocodiles, hippopotamus, fish, and aquatic birds of the region, they now form part of South Africa's most important conservation projects.*

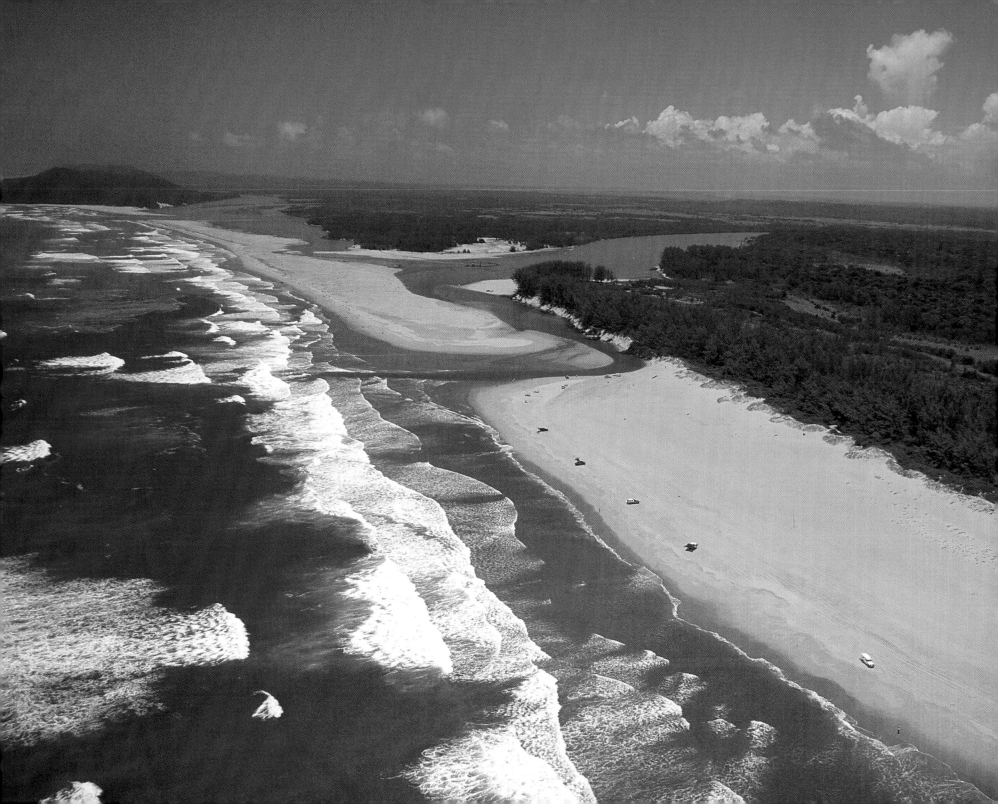

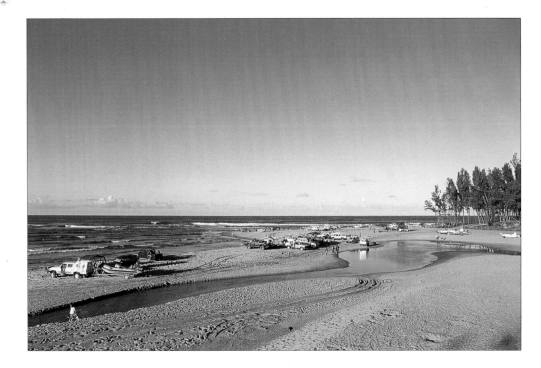

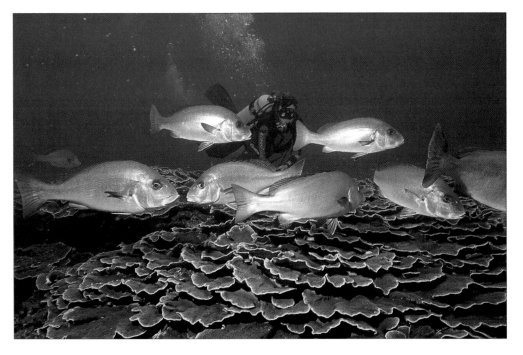

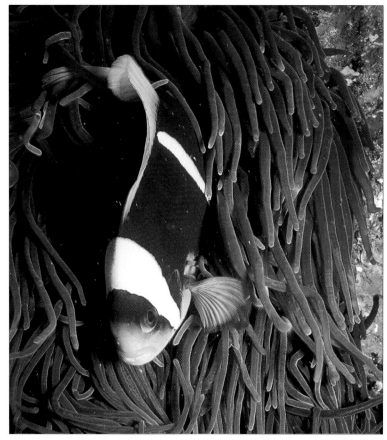

Top left *Although certain parts are popular holiday spots, the ecology of Sodwana Bay's kilometres of open beach — lapped as they are by the crashing waves of the Indian Ocean — is extremely sensitive to human influence.*
Left and above *The marine wonderland of Sodwana Bay, with its luminous corals and dazzling clownfish, is constantly under threat and conservation remains a priority along this coast.*
Opposite *The livelihood of the many villagers at Kosi Bay, fish are trapped in the nets of local fishermen as the tide recedes and are then easily speared.*
Overleaf left and right *With the prolific bird life of its tranquil lagoon, Kosi Bay on the easten seaboard of KwaZulu-Natal and just south of Mozambique, takes its name from the Zulu* ukosi *after the tawny eagles that wing its skies.*

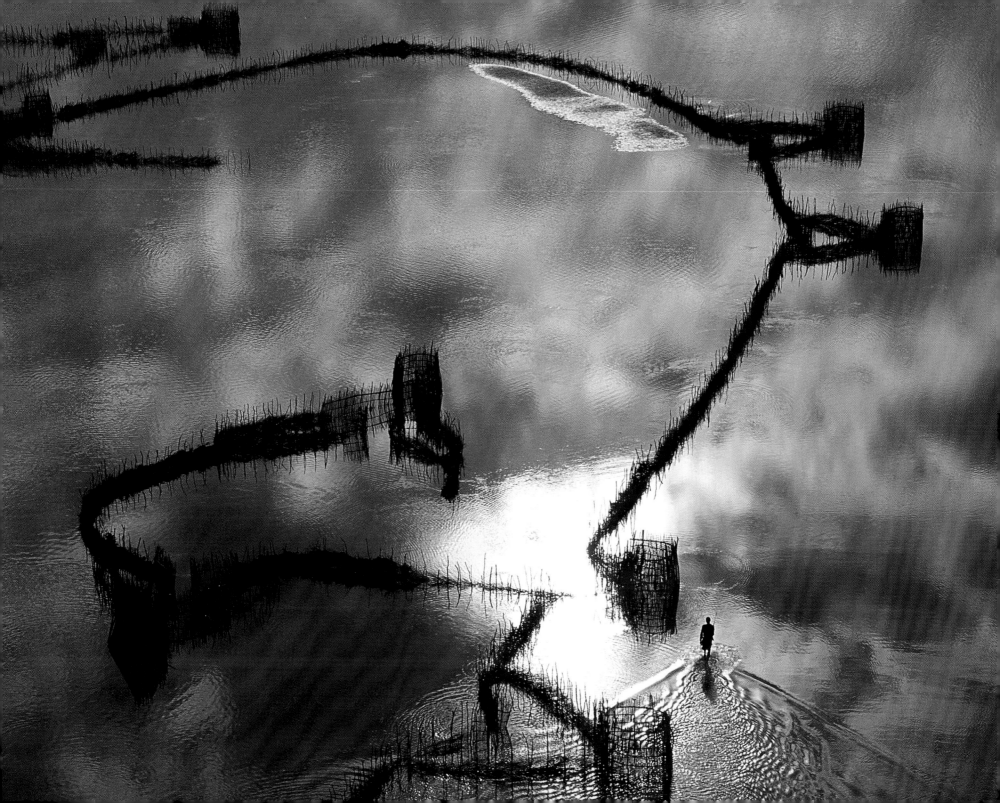

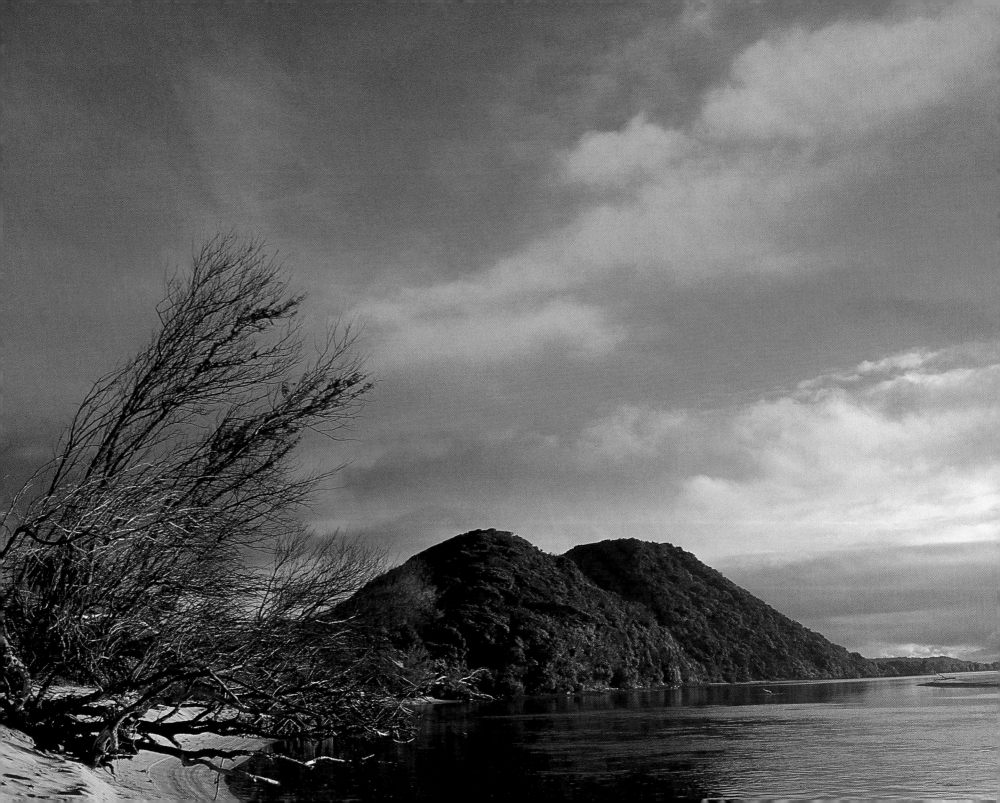

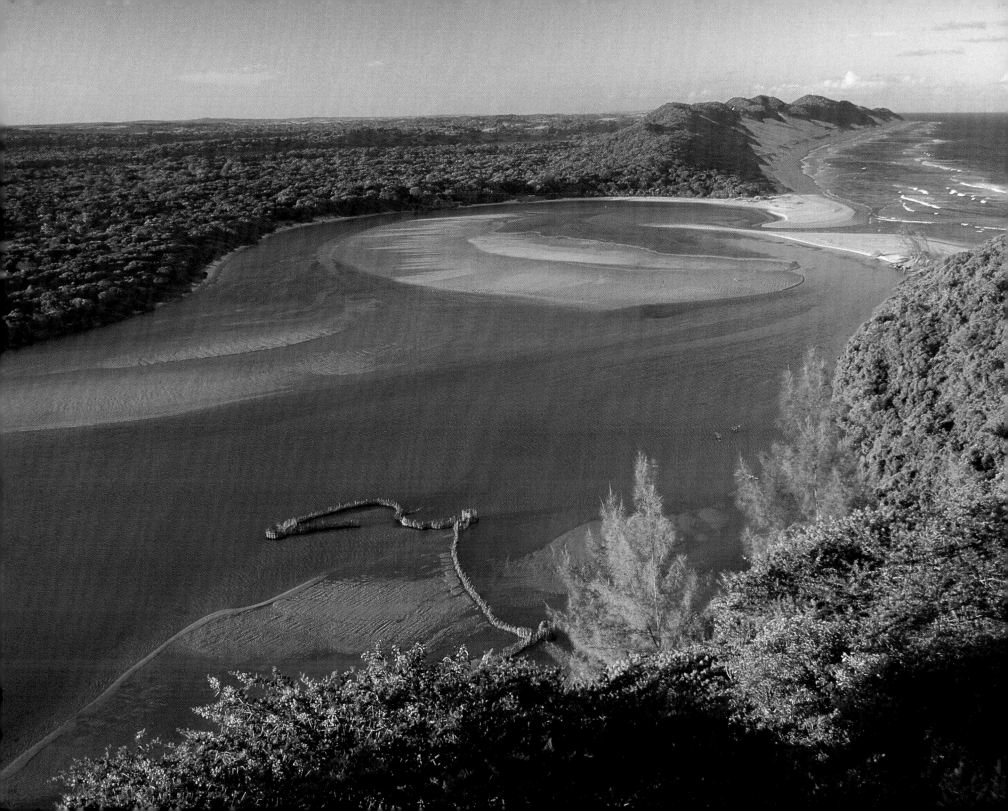

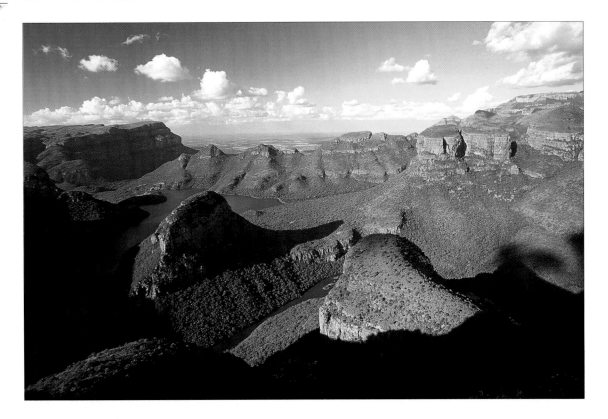

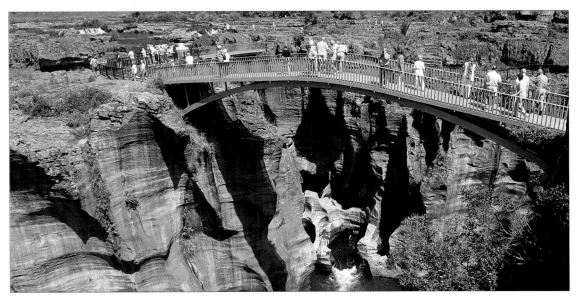

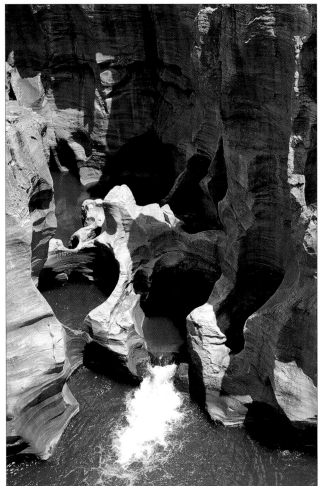

Top left As one of the subcontinent's most impressive gorges, the Blyde River Canyon is guarded over by the quartzite heads of the Three Rondavels.

Left and above Just beyond the Blyderivierspoort Reserve are the Bourke's Luck potholes, a series of nooks and crannies miraculously carved from the rockface by the constant motion of gushing water.

Opposite The 26-kilometre expanse of the majestic Blyde River Canyon, the central feature of the Blyde River Canyon Nature Reserve, sweeps along the rocky Escarpment down to the Lowveld.

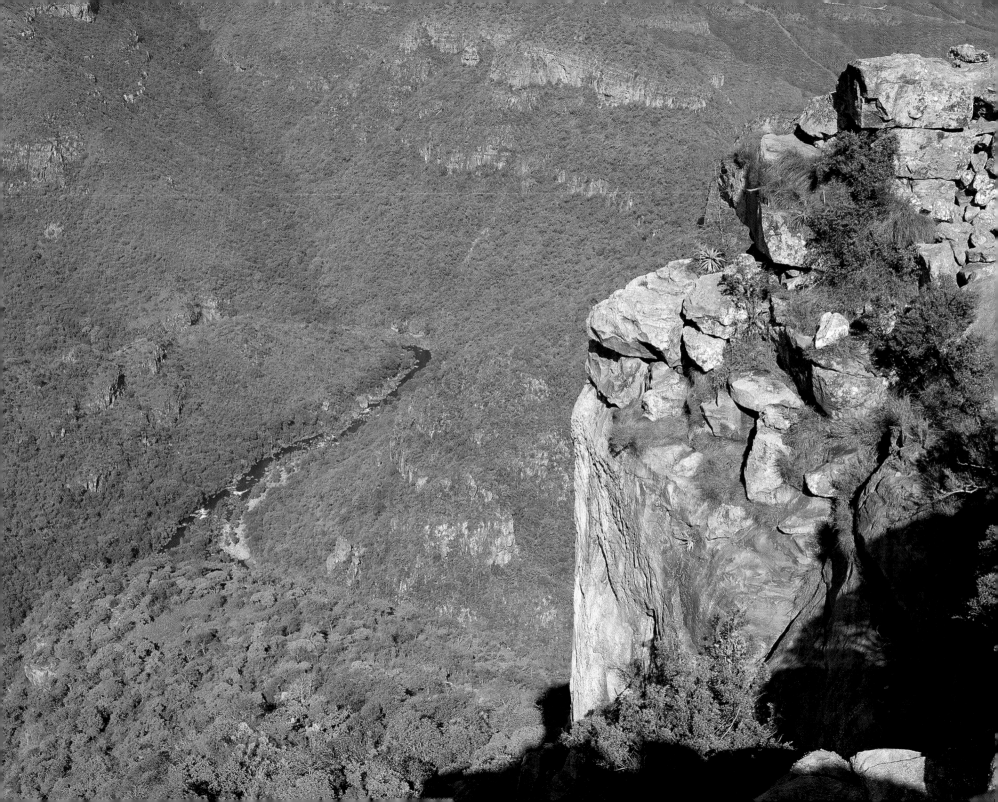

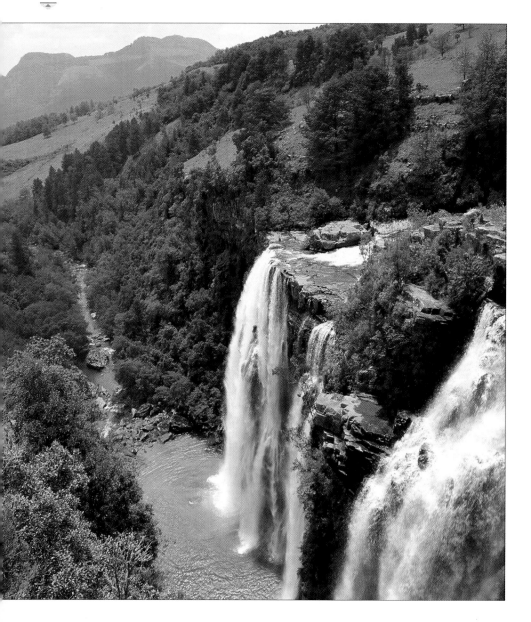

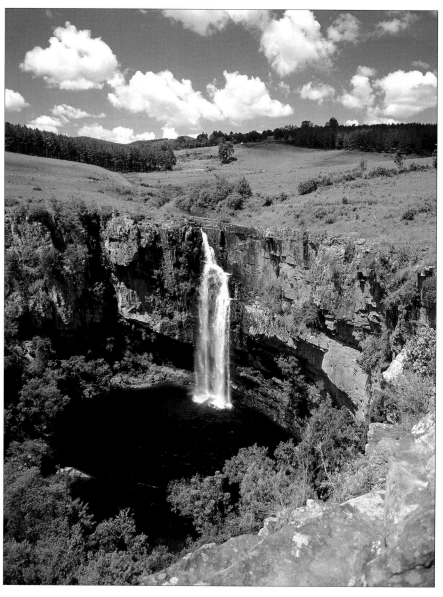

Above *The escarpment of what is commonly known as the Panorama Route is awash with magnificent waterfalls that fall as sheets down the sheer rock faces, but few are as impressive as the Lisbon Falls.*

Above right *Although during the dry winter months the river is little more than a stream, the water of the Watervalspruit tumbles down the 80-metre Berlin Falls following the rains of summer.*

Opposite *Named for the indigenous woodland at its summit rather than the plantations of alien pine that are all too common in the district, the Forest Falls crash in a tranquil pool below.*

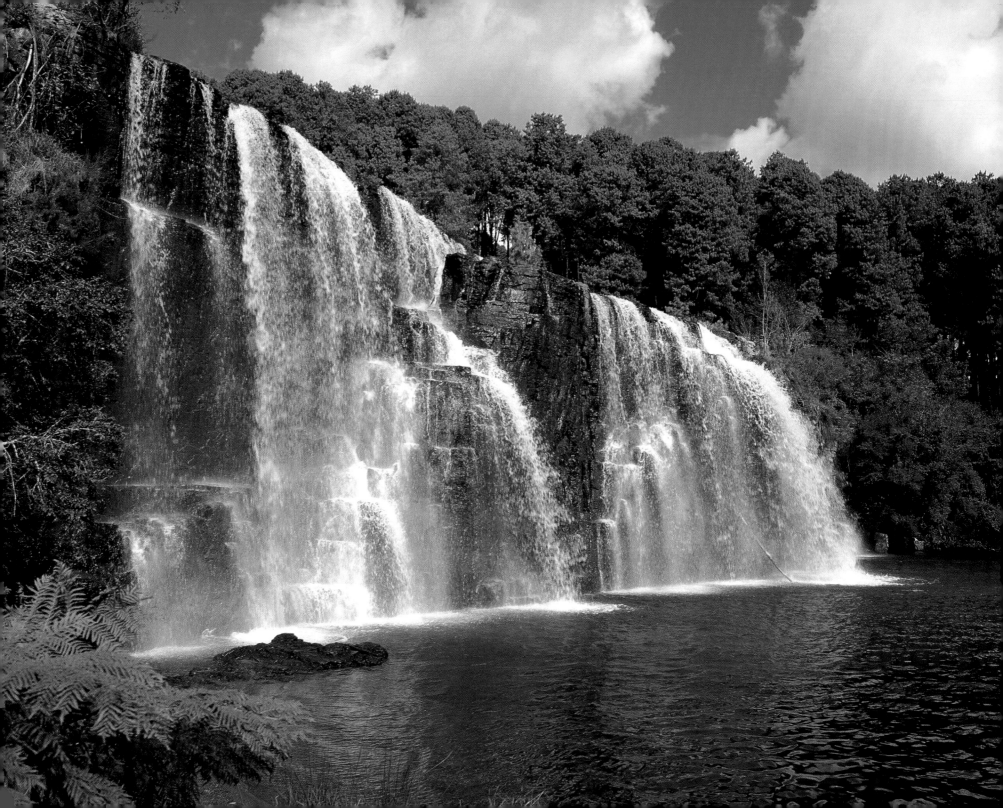

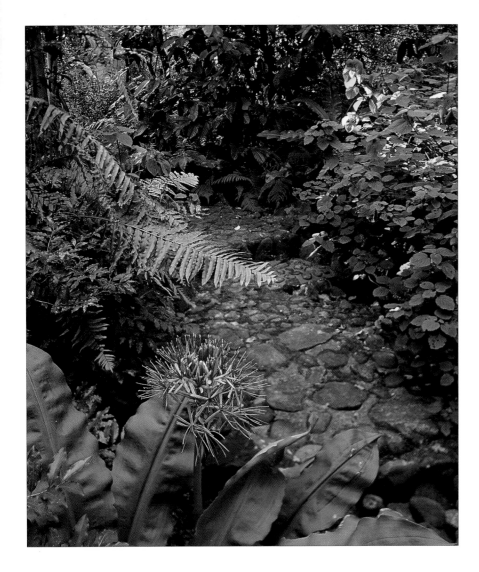

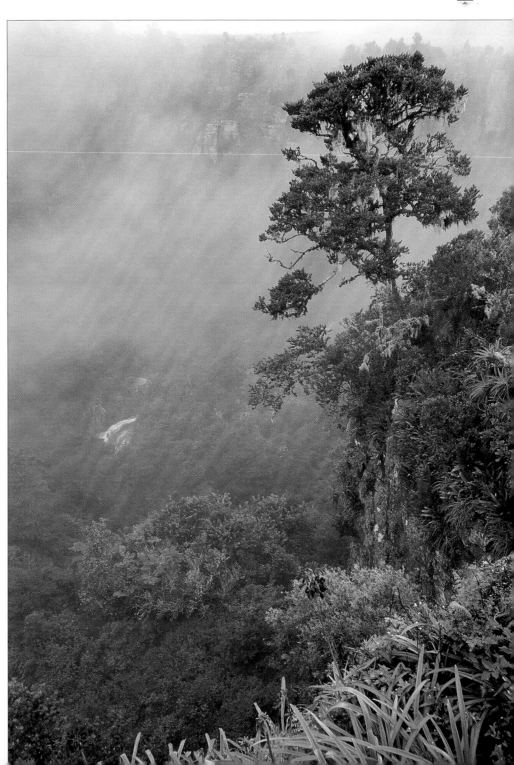

Opposite Although apparently rather desolate and inhospitable, the Driekop Gorge near Graskop — despite its rather sombre colours — is remarkably receptive to the aloes which are so characteristic of this landscape.

Above The pride of Nelspruit is its National Botanical Gardens, testimony to the fertile gound on which stands the town named after the three brothers who grazed their herds there.

Right The Pinnacle at Graskop is the most idyllic viewpoint from which to view the Edge of the Lowveld, a sheer drop of 700 metres shrouded in mist.

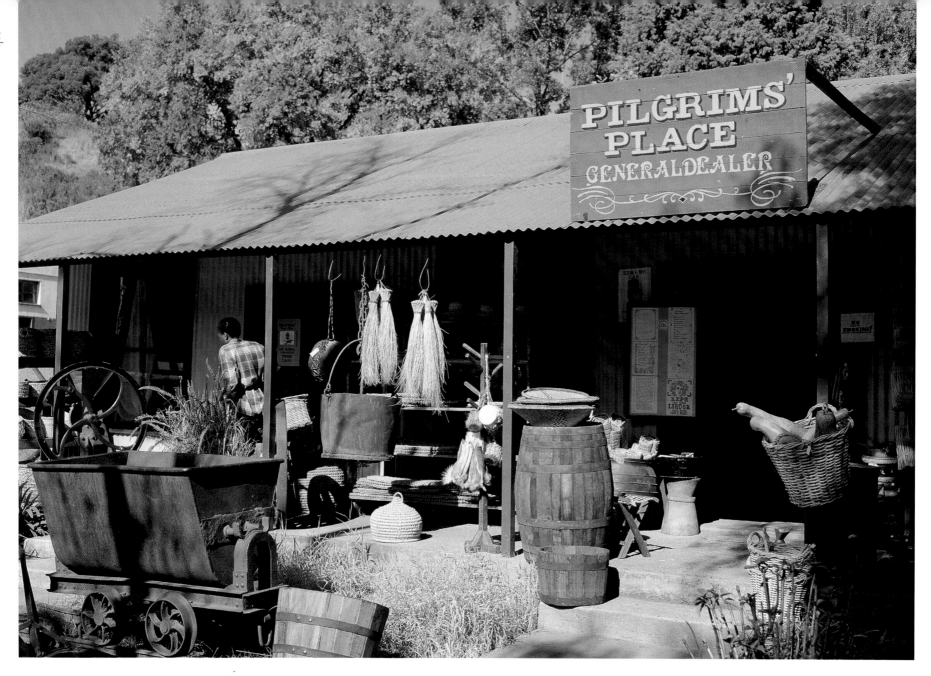

Above The town of Pilgrim's Rest, which describes itself as a 'living museum', was founded by gold-digging pioneers of what was to become South Africa's most lucrative industry.

Opposite In a region famed for its abundant trout, the Kamberg Nature Reserve on the Mooi River is perhaps the most revered of the area's many fly-fishing spots.

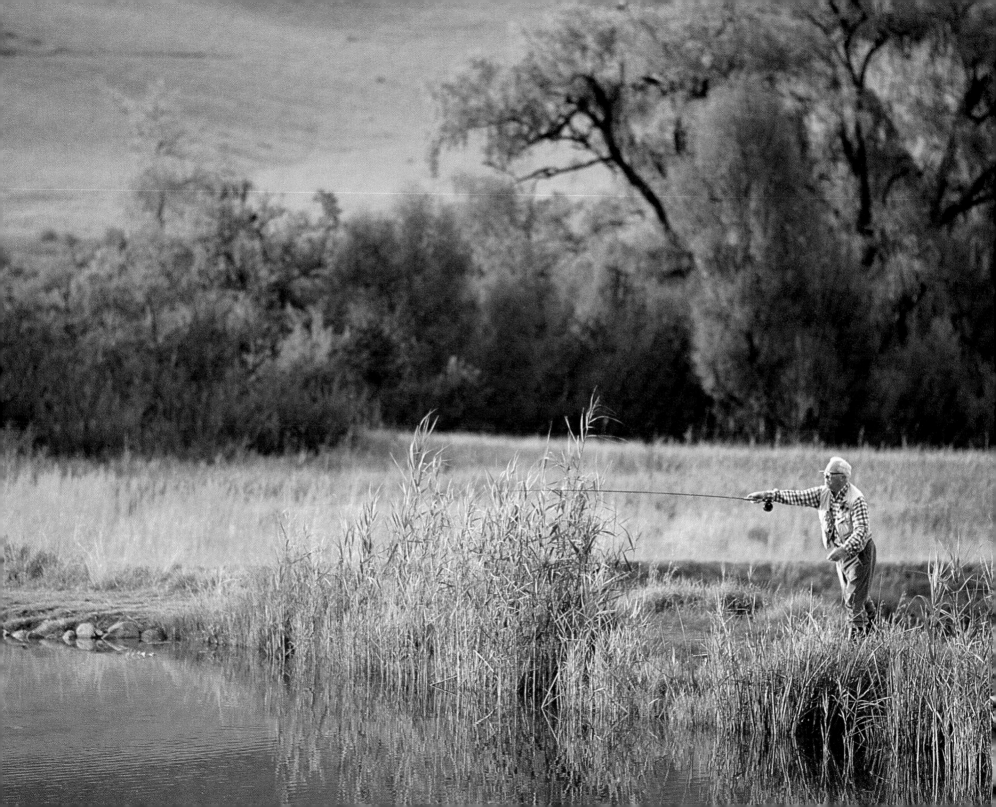

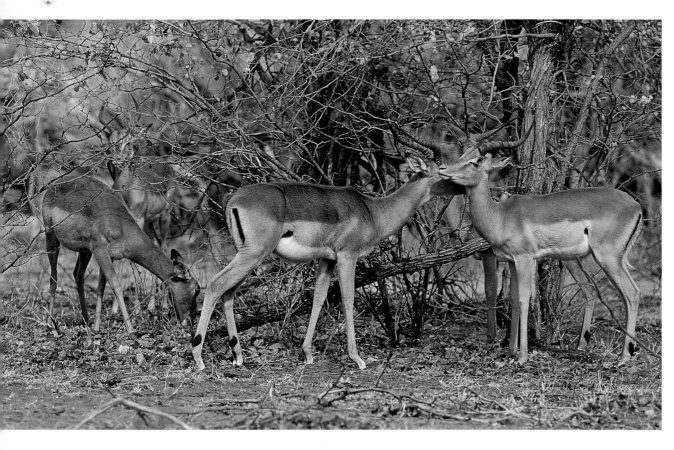

Above, right and overleaf *The Kruger National Park —
covering some 20 000 hectares and larger in size than
countries such as Israel and Wales — is acclaimed as one
of the greatest wildlife reserves in the world, and is certainly
South Africa's most renowned and most treasured asset. The
Park boasts an extraordinary diversity of wildlife, from the
impala to the great king of the beasts, the lion, and the
zebras which graze on its open veld.*

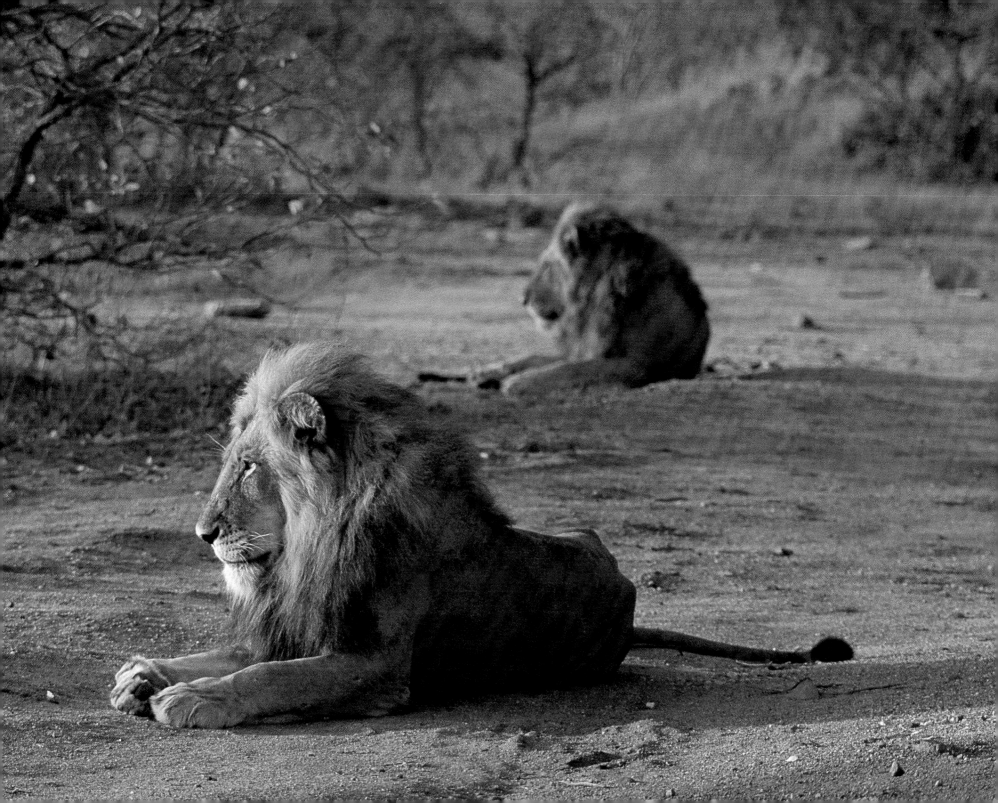

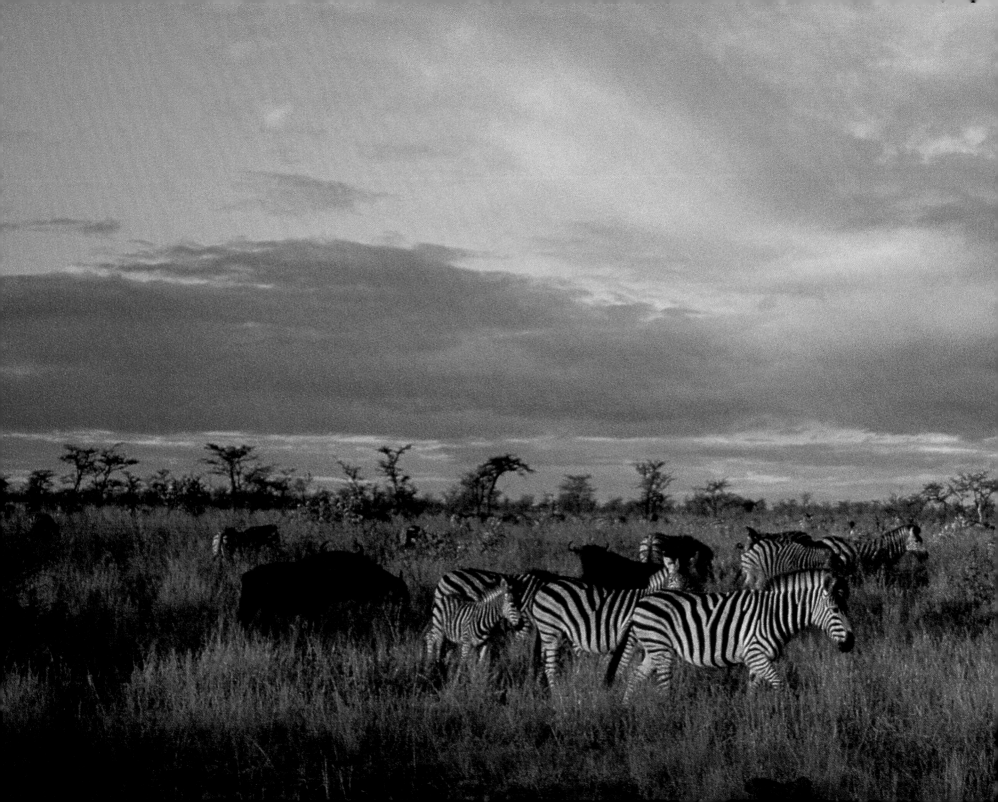

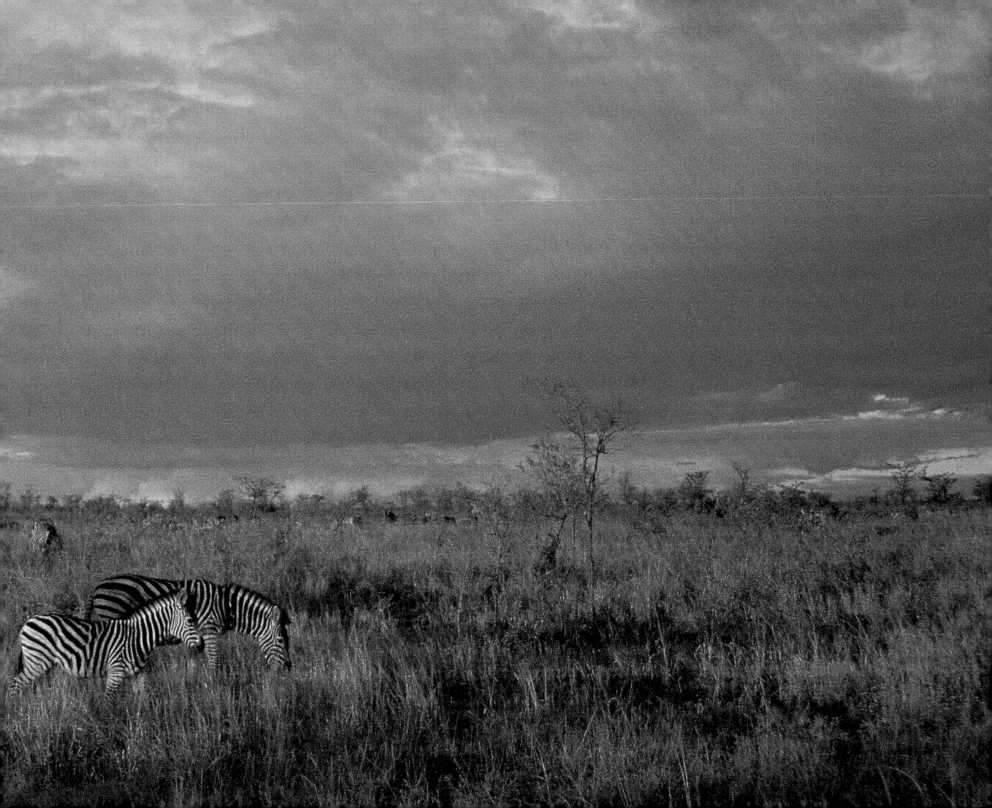

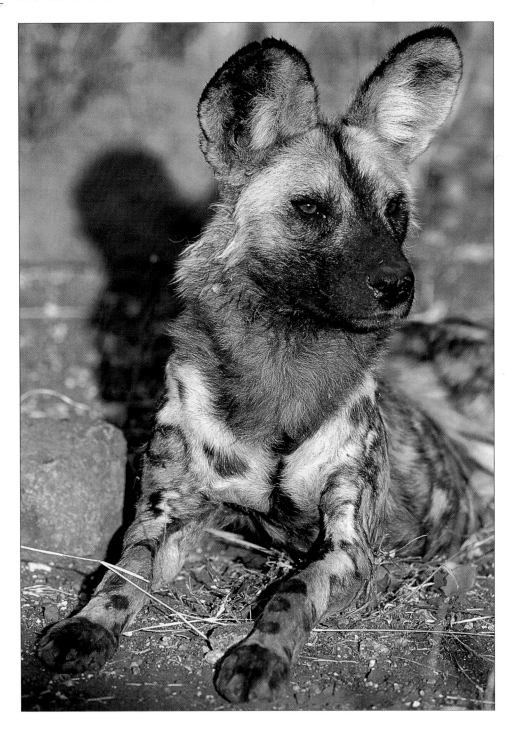

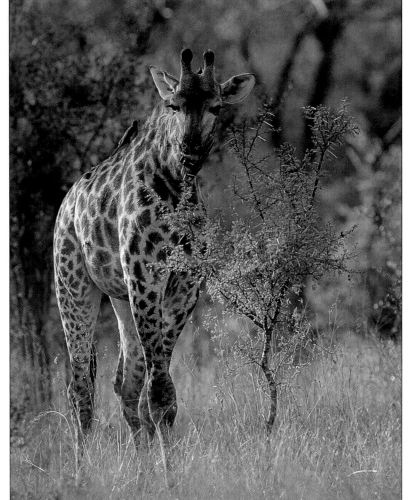

Left and above *In an untamed wilderness seemingly unchanged for thousands of years, the expansive Kruger National Park of today allows animals such as the wild dog (left) and giraffe (above) of this mopane and acacia veld to live side by side, if not in harmony then certainly as nature intended.*

Opposite *Punctuating the bush and savanna grassland of the Kruger National Park is a range of accommodation much like Olifants Camp which caters for the increasing number of visitors who gather in the Park every year.*

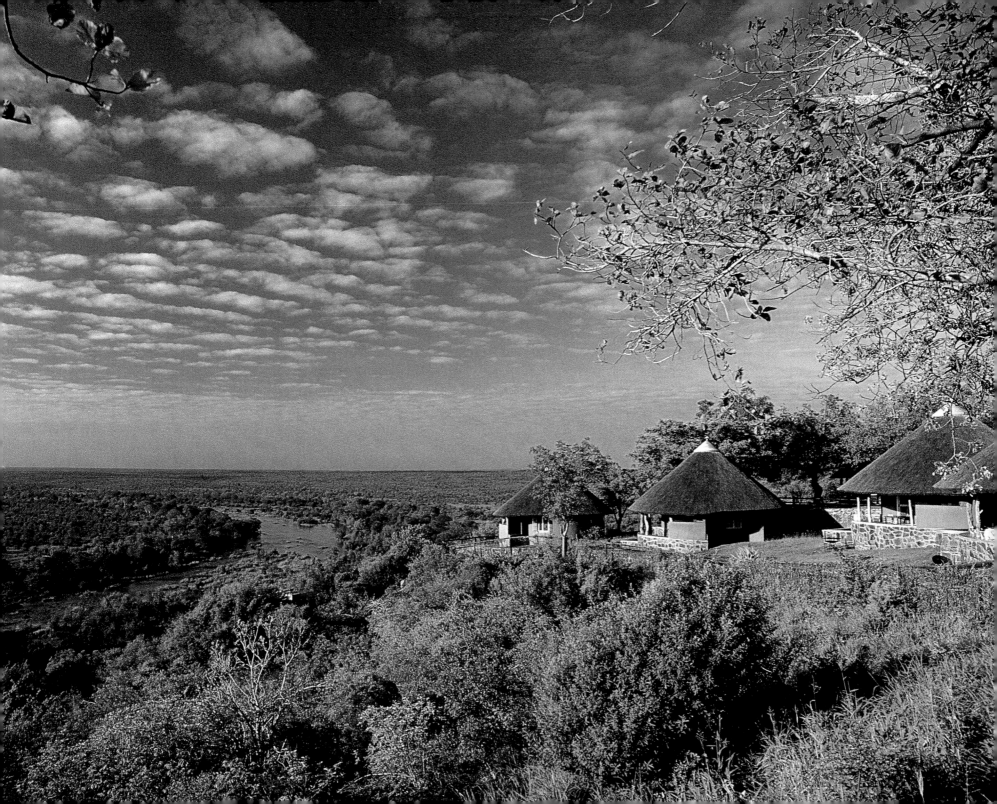

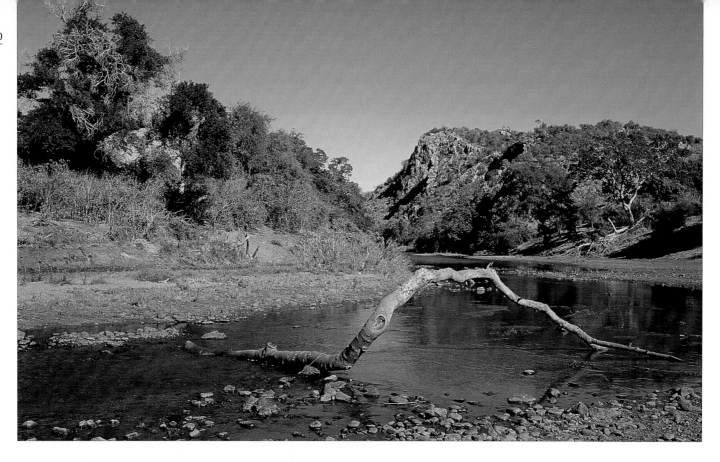

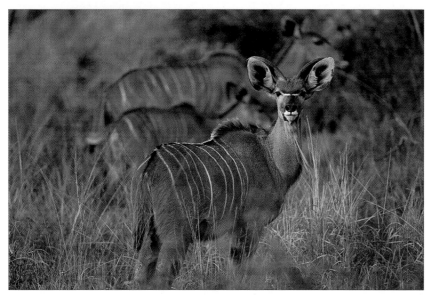

Above, left and right *In a Lowveld countryside not blessed with an abundance of water, the animals of the Kruger National Park rely on watering holes and perennial rivers. During the dry months, game-watchers are more likely to see wildlife such as young kudu and elephant drinking from or bathing in the few remaining waterholes.*

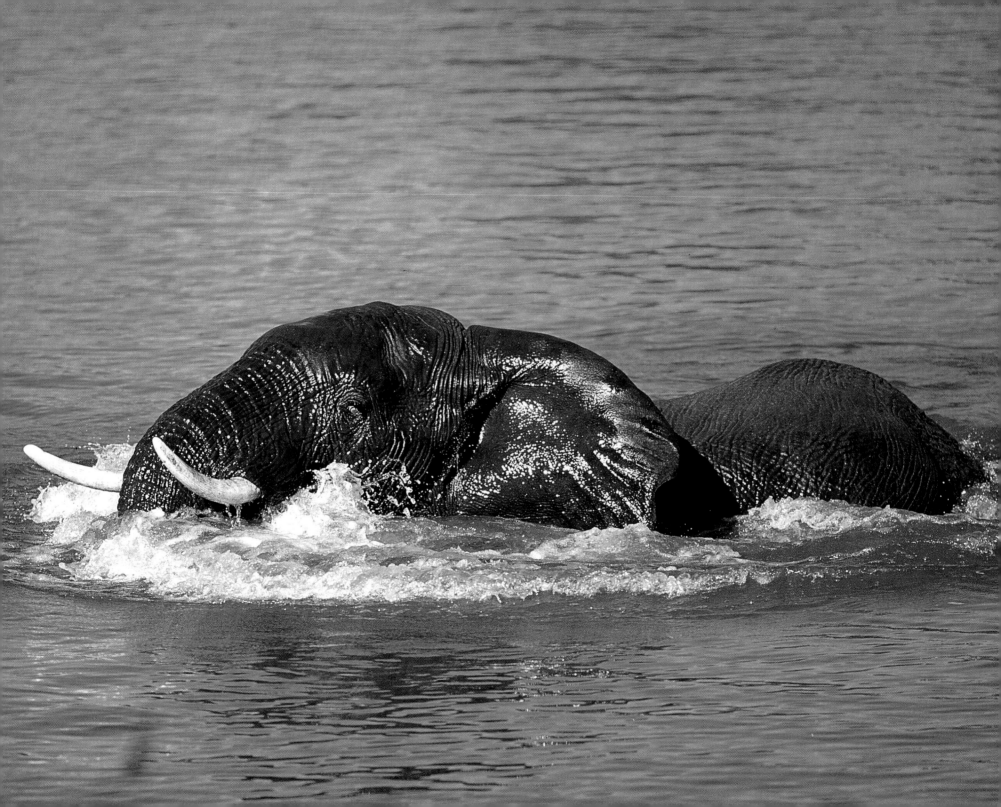

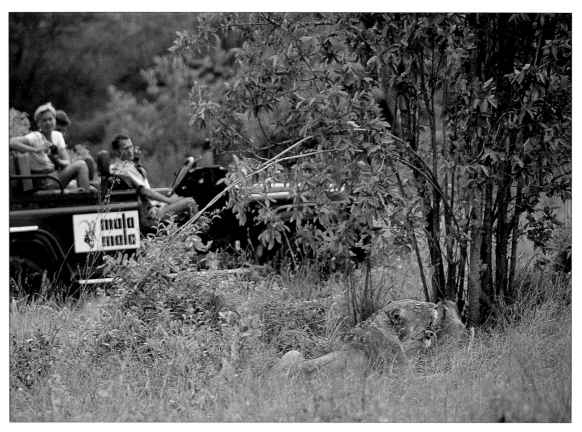

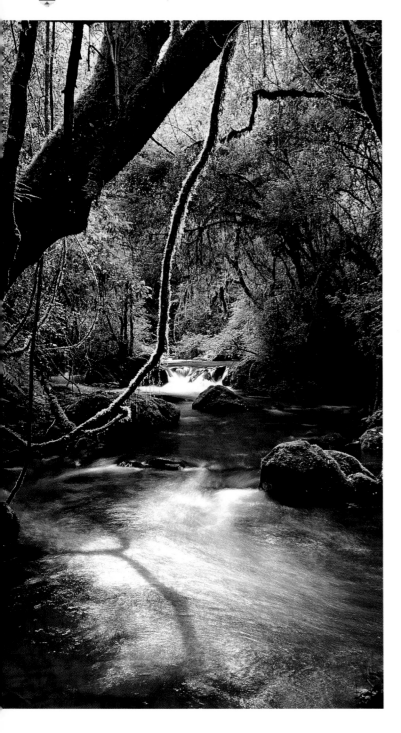

Left *Following the dry winter months, many of the Lowveld's rivers and streams are filled again with the summer rains and the wildlife of the area no longer depend entirely on the few waterholes for sustenance.*
Above *Whether within the confines of Kruger or at one of the exclusive private reserves such as Mala Mala, the rewards for the visitor remain the same: close encounters of the wild kind.*

Opposite *As in the Kruger Park, the surrounding private reserves boast an exhilarating array of wildlife. Here a hippopotamus wallows in the waters of Sabi Sabi, one of the reserves on the southwestern fringe of the Park.*

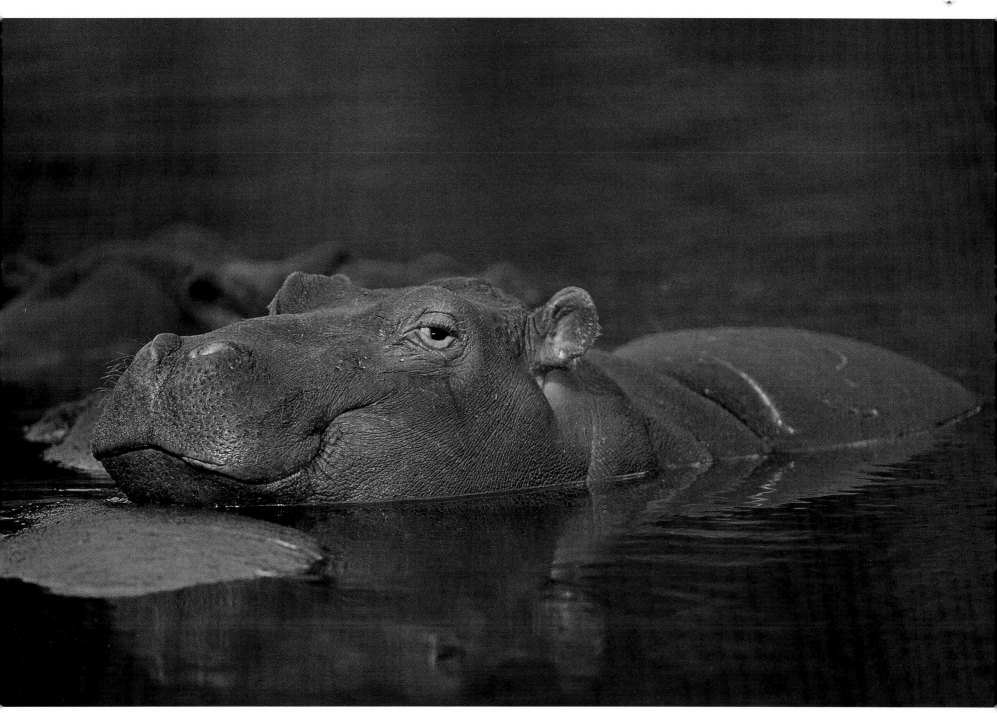

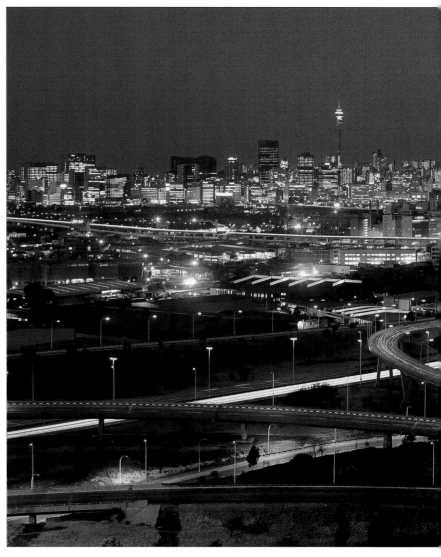

Left and above Johannesburg's ever-changing profile
of towering glass structures and imperial architecture is
woven together by a network of thoroughfares and highways
distinctive of the thriving first-world city it has become.

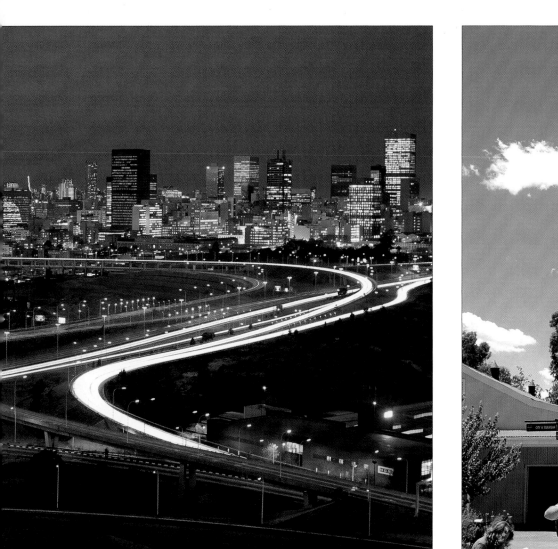

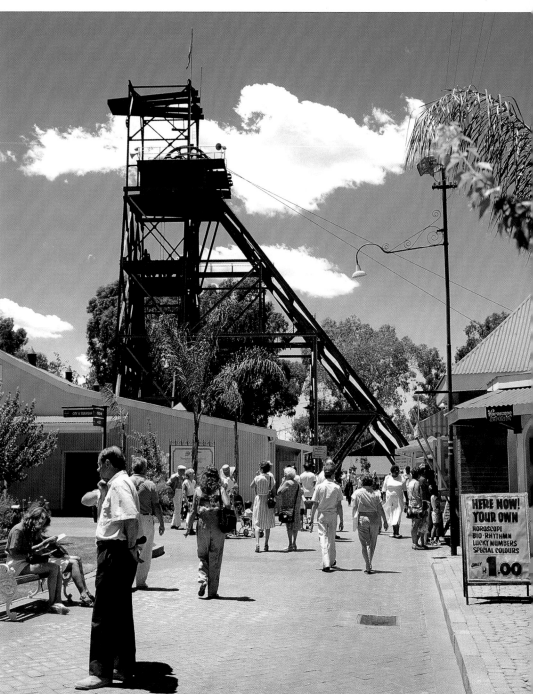

Right *Located at Crown Mines, Gold Reef City — with its horse-drawn omnibuses and nineteenth-century fun fair — is a recreation of Johannesburg as it was at the height of its early mining operations.*

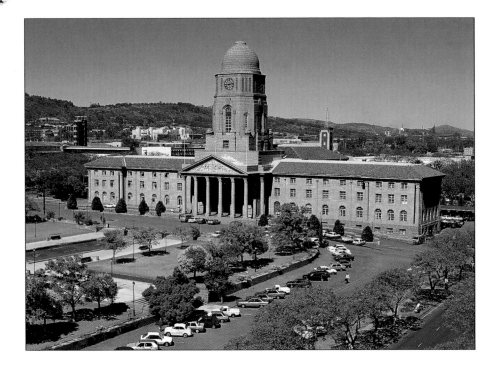

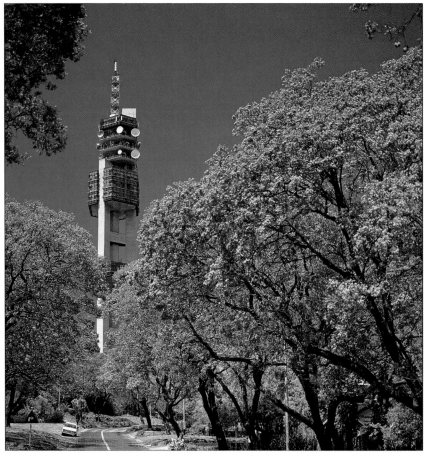

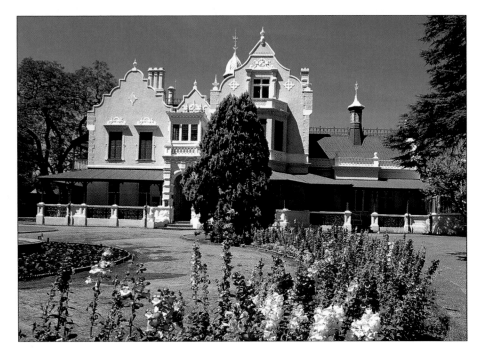

Top left Pretoria's City Hall located on Bosman Street is the heart of the city which, nestling in the eastern foothills of the Magaliesberg, is the country's adminsitrative capital.

Left Melrose House was built as a private residence during the Victorian era, but today it is a museum commemorating the signing of the Peace of Vereeniging which brought to an end the hostilities of the Anglo-Boer War in 1902.

Above Although brtilliantly colourful when in bloom, the jacaranda trees that are now synonymous with Pretoria are not indigenous and were introduced from Rio de Janeiro in 1888.

Opposite Designed by Sir Herbert Baker, South Africa's most prolific and esteemed architect, in his much-favoured amphi-theatre style of ancient Greece, the Union Buildings on Meintje's Kop overlook the country' capital.

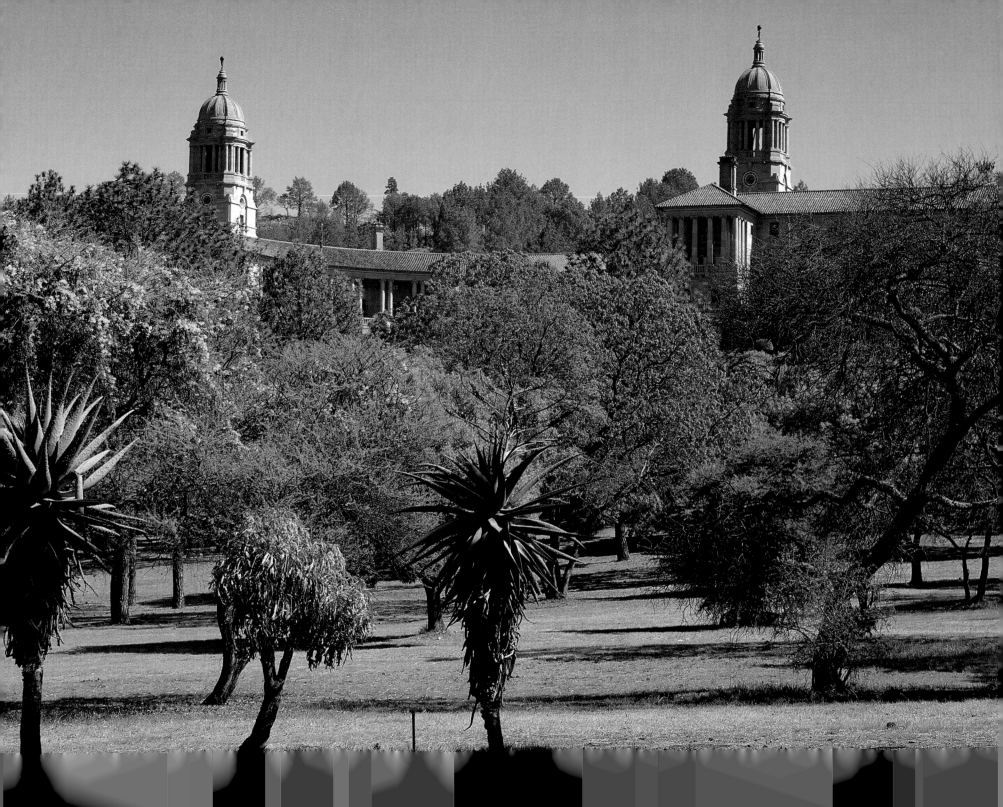

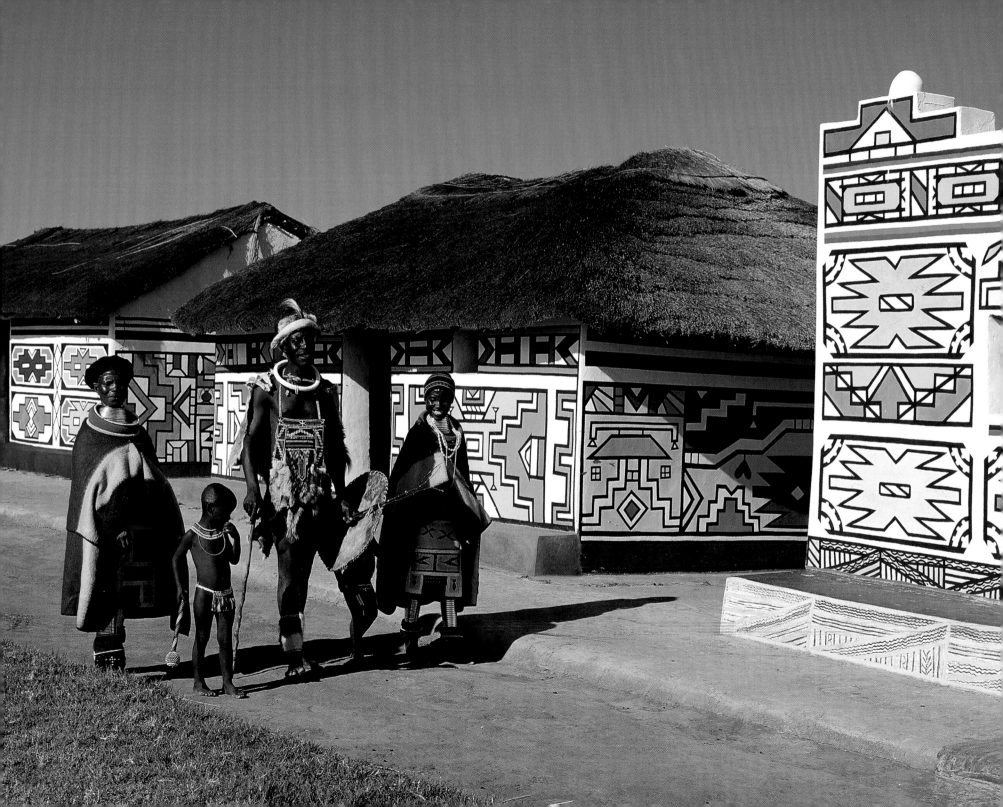

Opposite, above and right Like all
South Africa's people, many of the Ndebele
have sacrificed much of their heritage to
adopt Western lifestyles, but the bold colours
and geometric designs that adorn their
clothes, handwork and the walls of traditional
kraals remain their most inspiring legacy.

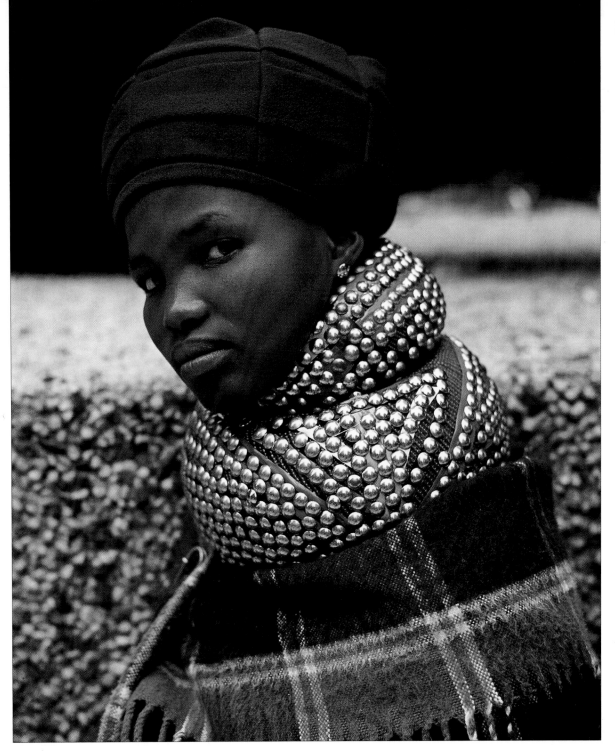

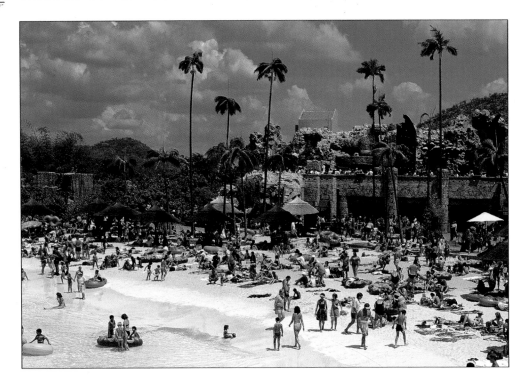

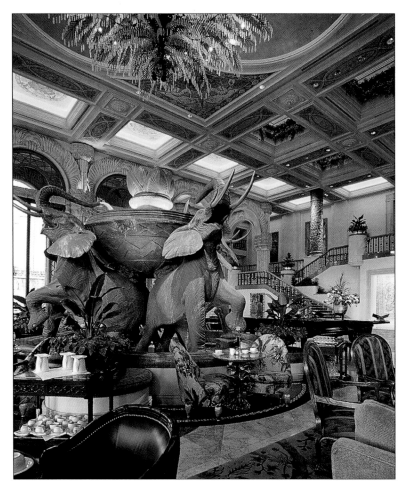

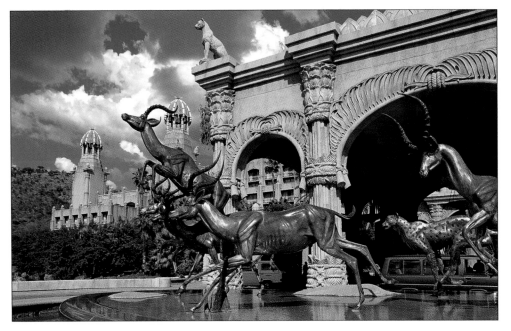

Top left *The Lost City complex flourishes in a rather austere landscape and its creators have even brought ocean waves to its parched 'shores'.*

Left *Steeped in the mythology of Africa, the Palace of the Lost City is fronted by the Cheetah Fountain, a magnificent sculpture depicting the hunt of the cheetah.*

Above *Beneath the gilded domes and soaring turrets of the Palace of the Lost City lies a sumptuous interior of marbled floors, fluted columns, and crystal chandeliers.*

Opposite *Although the lakes, forests and rolling seas of The Lost City rose from the land in recent times, they introduce an exciting illusion of a long-forgotten world.*

Overleaf *The plush hotels of the Sun City complex boasts some of the country's most luxurious leisure facilities and certainly one of its finest golf course.*

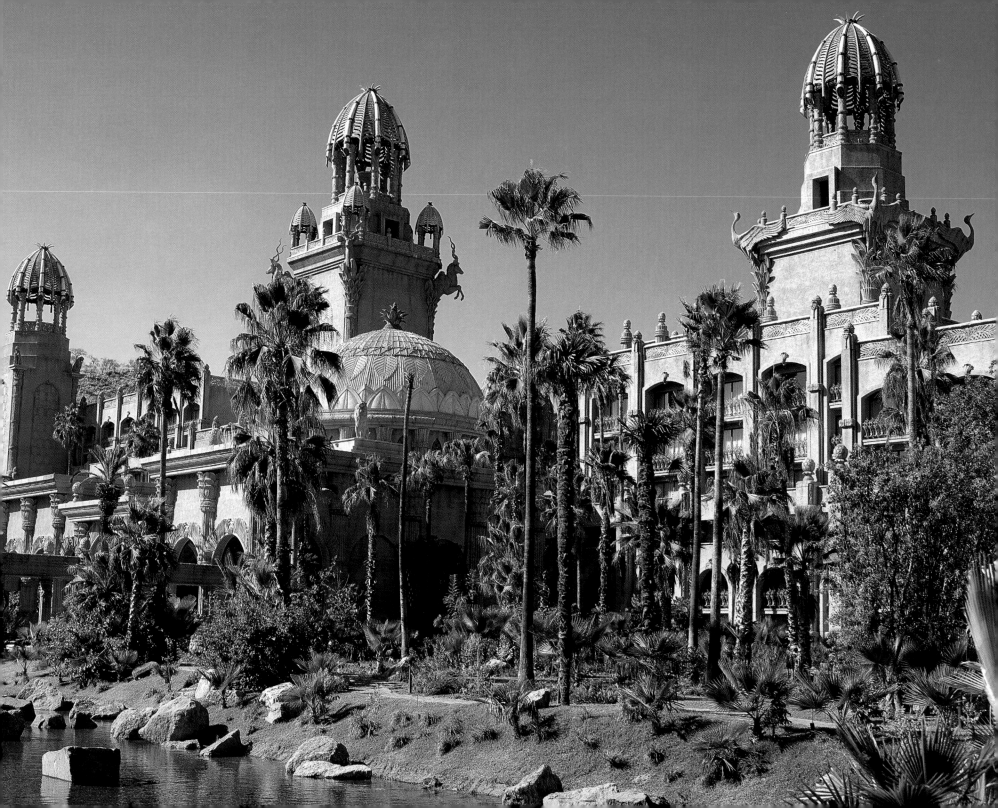

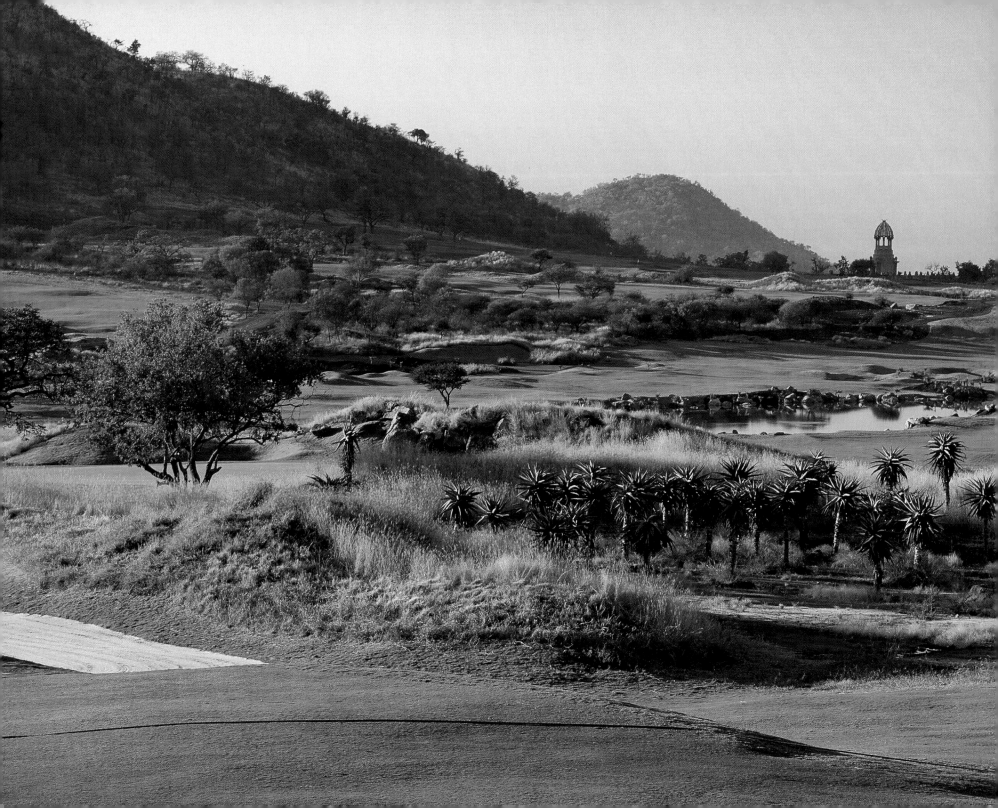

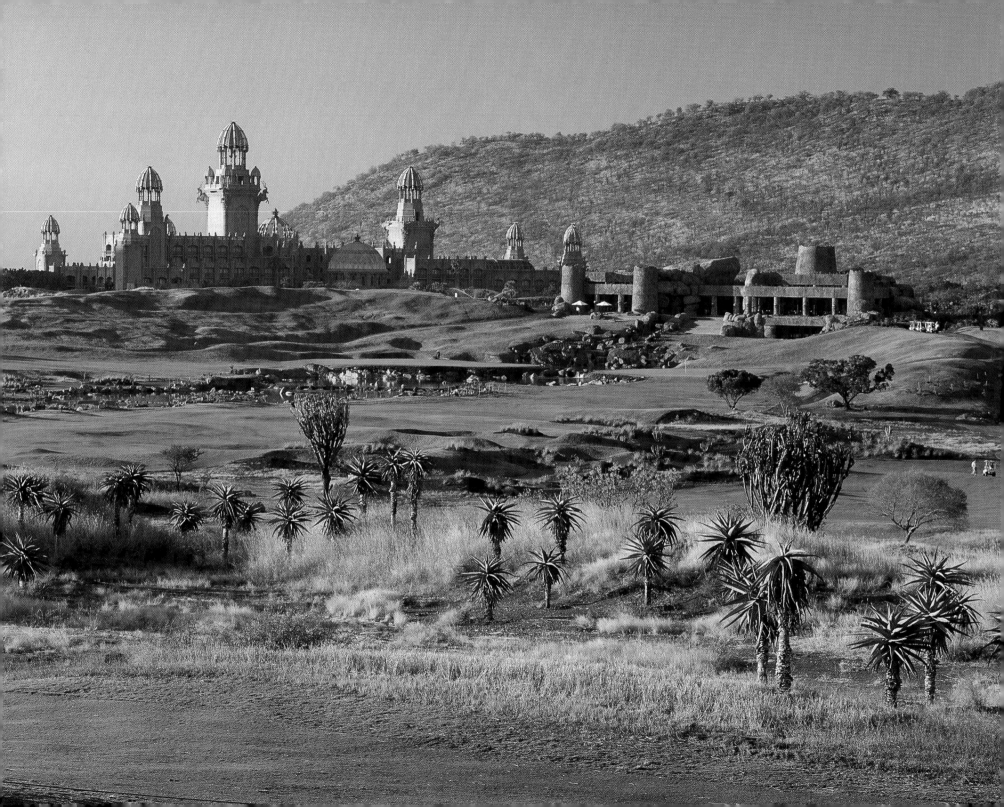

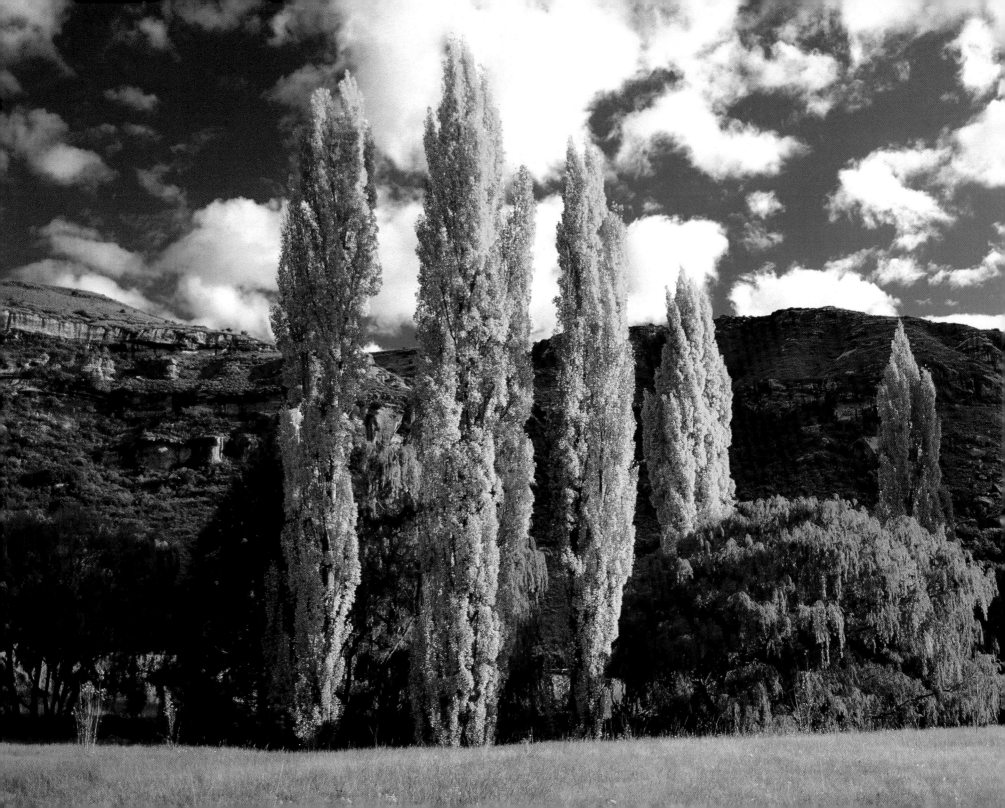

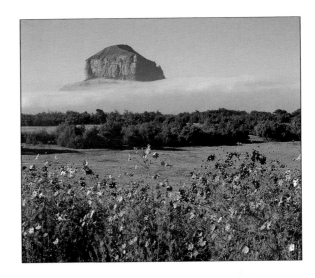

Left *A rank of tall golden poplars lines a long and dusty road leading to the Free State town of Clarens, named after the picturesque Swiss hamlet in which President Paul Kruger spent his last days.*

Right and below *Backed by the Maluti Mountains, fields of wild cosmos and golden sunflowers seem to have been painted onto a landscape cut by the Van Reenen's Pass.*

Overleaf left *Set in the Little Caledon River valley, the over 6 000 hectares of the Golden Gate Highlands National Park is presided over by two giant, yellow-stoned sentinels known as the Golden Gate.*

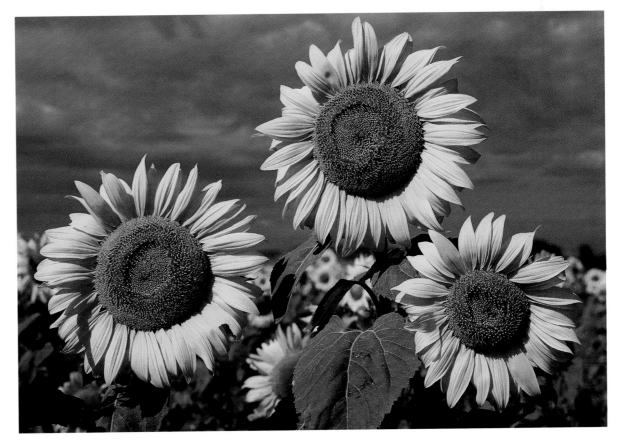

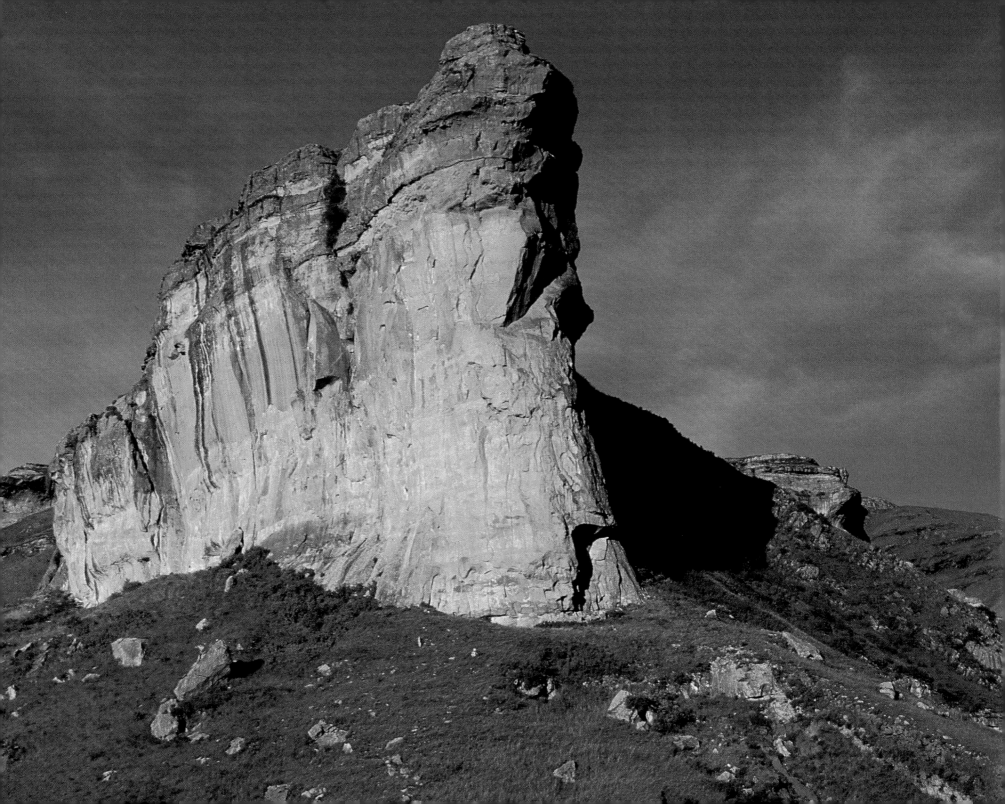

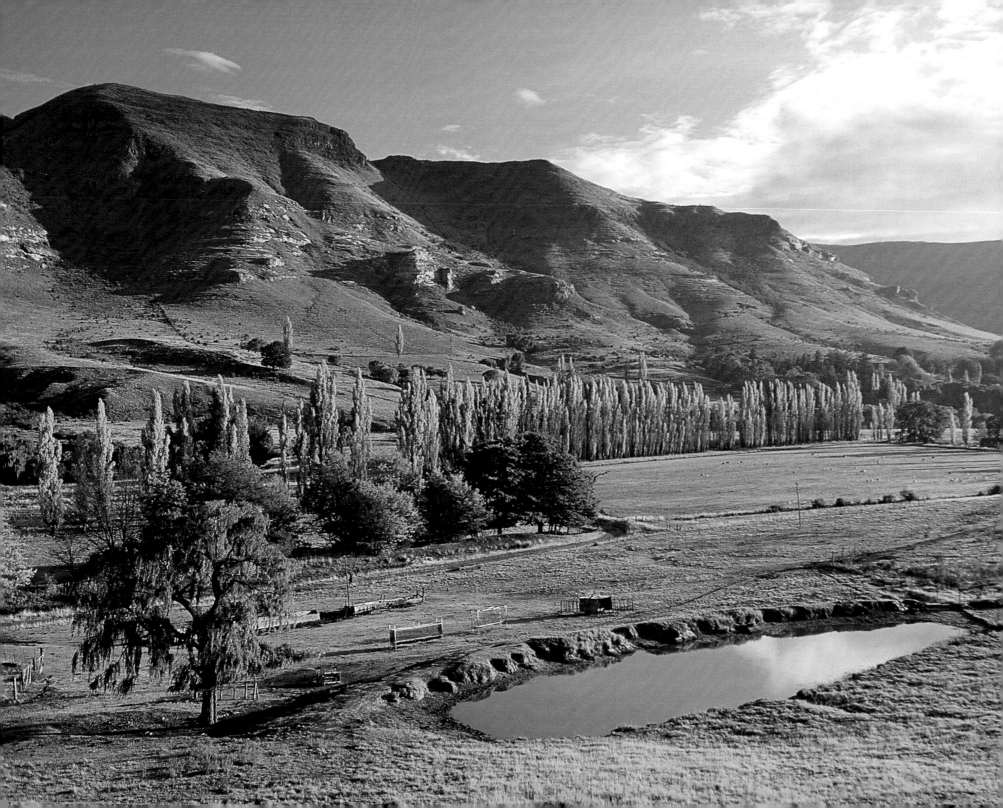

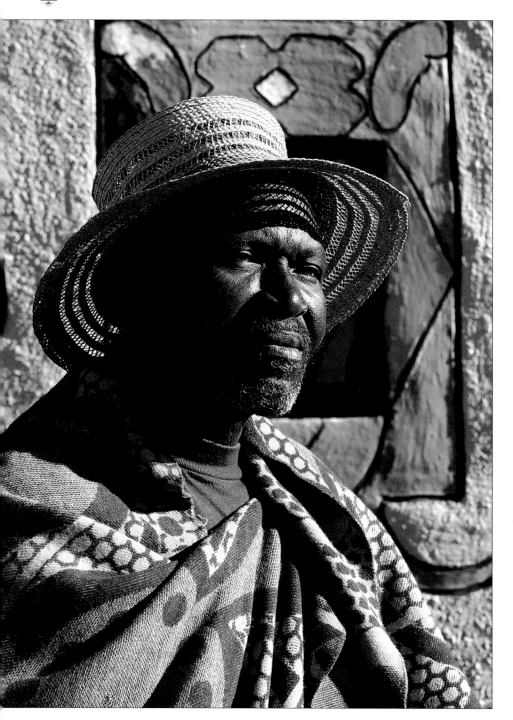

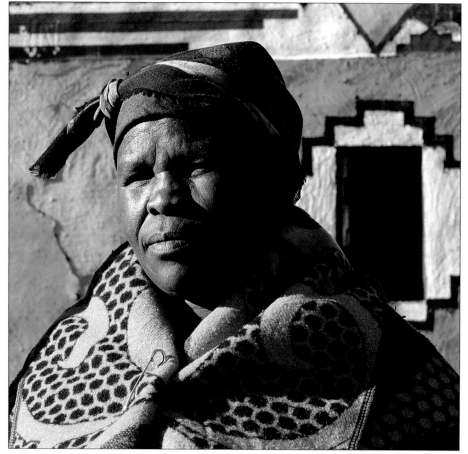

Previous page *A glistening lake fringed with poplars and guarded by mountains is not an image usually associated with the Free State, but such is the world of Clarens.*

Left, above and opposite *To the south of Golden Gate lies the Mountain Kingdom of Lesotho, the traditional home of the Basotho whose colourful homesteads dot its landscape.*

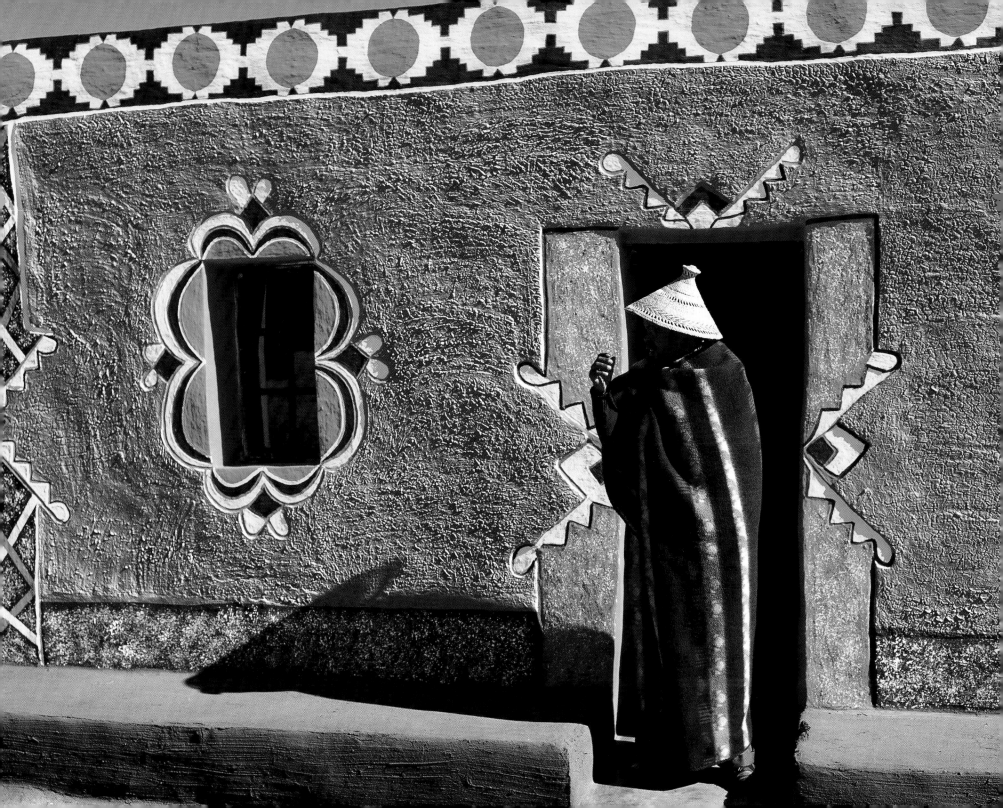

Above *The Augrabies National Park forms the crown of the arid northern Cape, which — despite its seemingly parched veld — is home to rhino, leopard, birds of prey and unique flora.*

Opposite *As the great Augrabies River sends a flood of water rushing over the Augrabies Falls, a sandstorm breaks in the hills above and the power of nature's force is felt by all who witness the spectacle.*

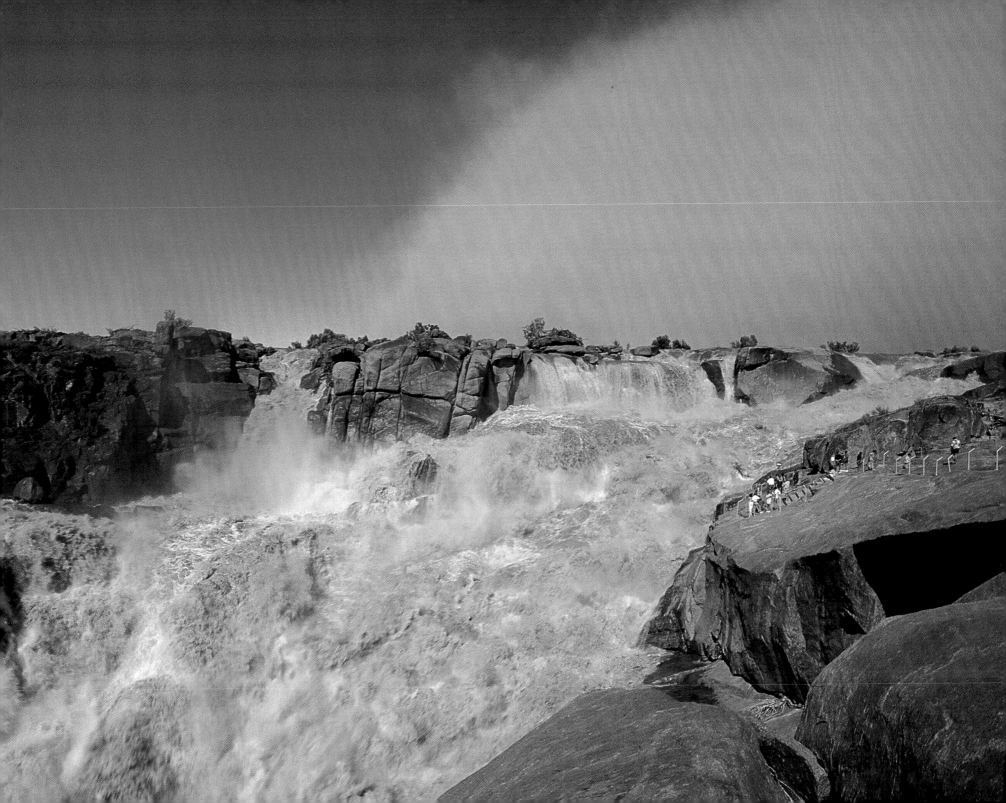

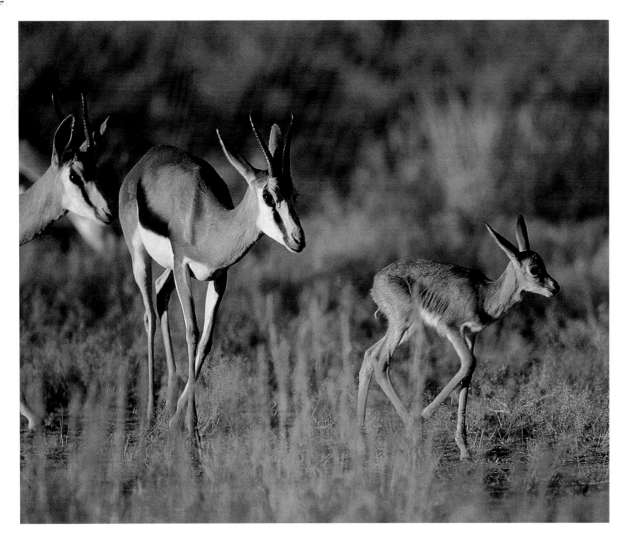

Above *The most abundant of southern Africa's antelope, springbok — found in many of the country's more arid wildlife areas — pronk across the Kalahari veld.*

Right *One of the most endearing of the region's wildlife, ever-alert suricate sun themselves outside a family burrow on a cold Kalahari morning.*

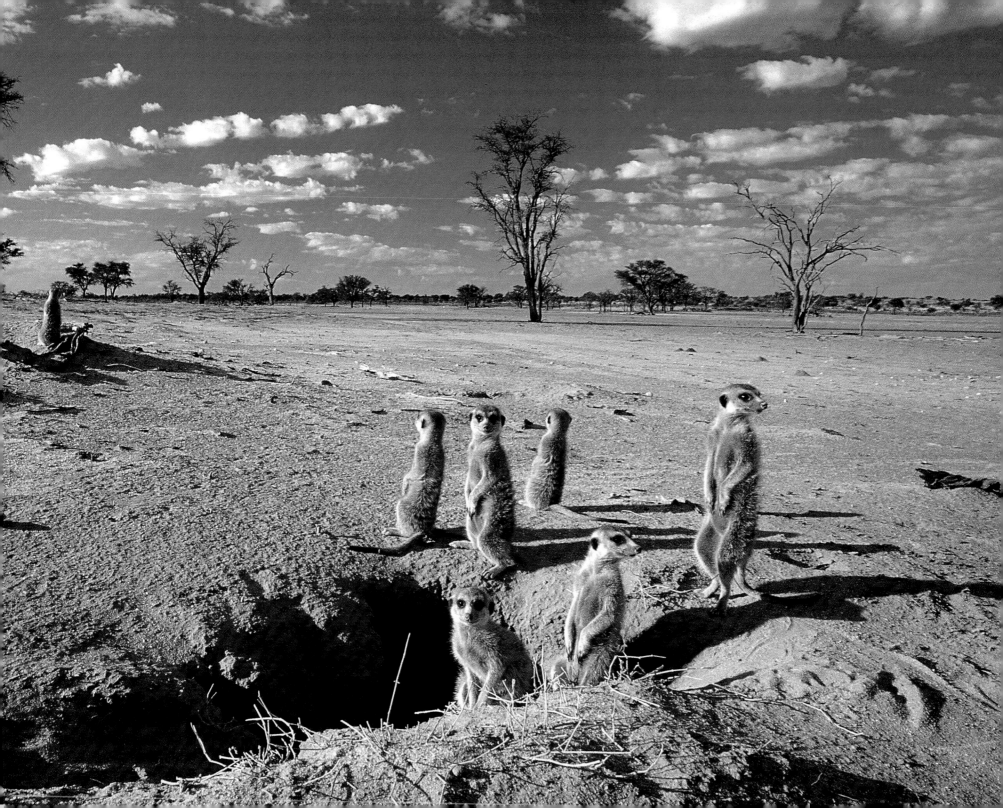

Opposite *So named because indigenous San hunters once hollowed out is fibrous branches to use as quivers for their arrows, the Quiver tree is a common sight in the stormy Augrabies Falls National Park.* **Below and right** *Although wild animals are no longer found in such great numbers, the Kalahari is nevertheless rich in wildlife, including springbok, gemsbok, cheetah and the magnificent lions so characteristic of the region.*

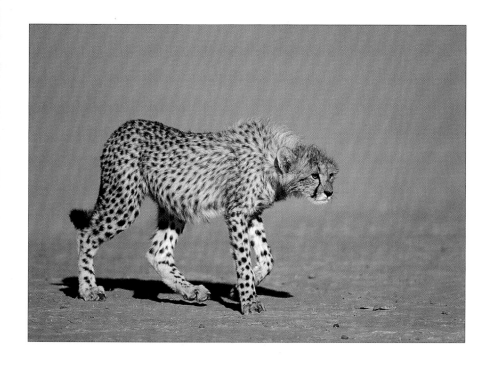

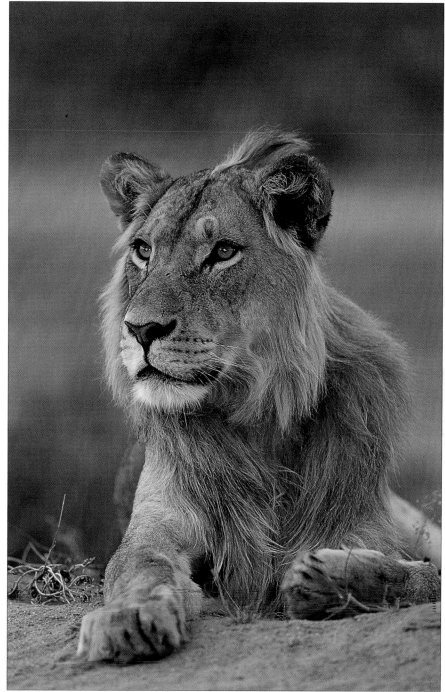

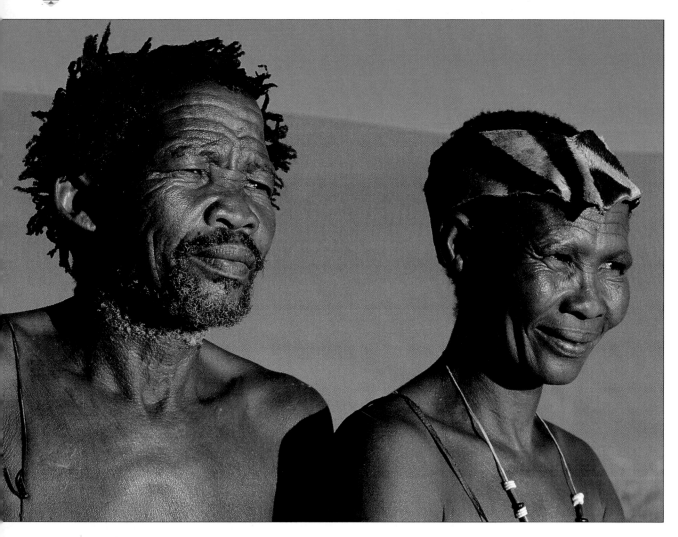

Above *All but lost to world at the hands of the colonialists and the Western lifestyle they brought with them, few of today's San people remain in the Kalahari and even fewer follow the customs of their time-honoured ancestors.*

Right *As distinctive of the Kalahari as the sands of the red dunes themselves, gemsbok (or oribi) have adapted remarkably well to the harsh and often gruelling lifestyle offered by this harsh, sun-baked land.*